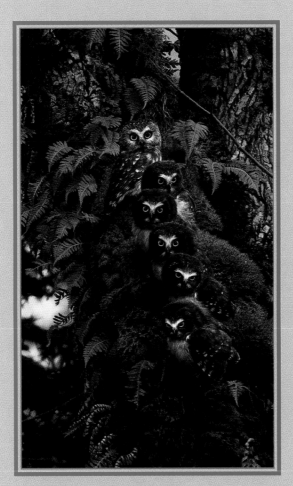

# *More* WILDLIFE PAINTING

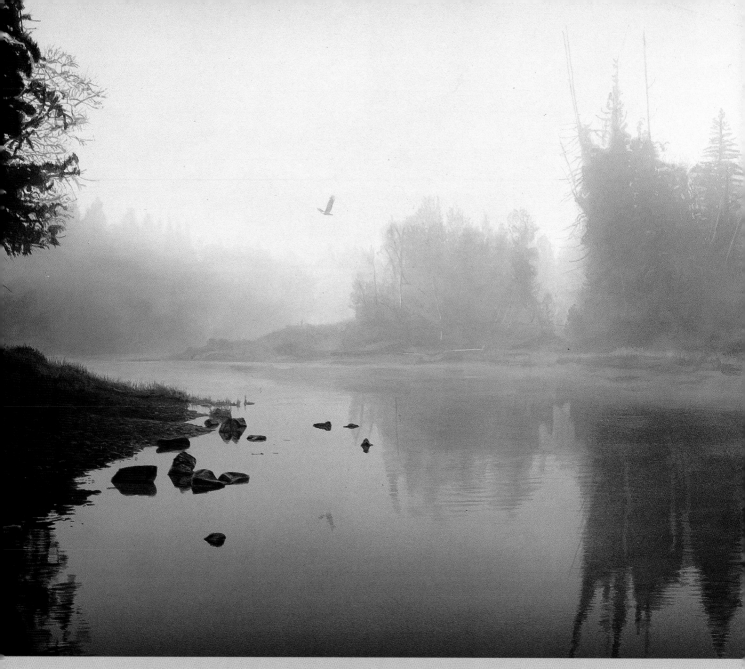

# More
# WILDLIFE
# PAINTING
## Techniques of Modern Masters

### SUSAN RAYFIELD

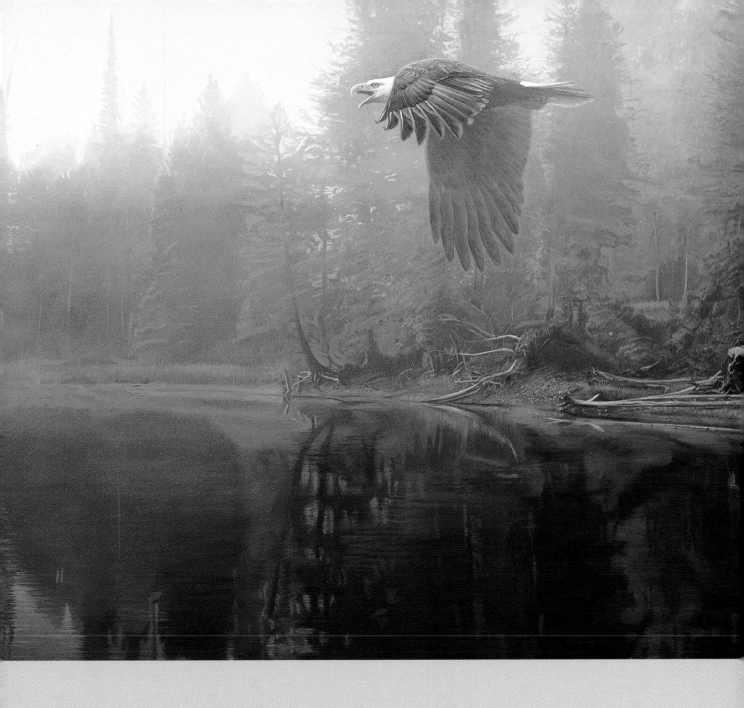

# WATSON-GUPTILL PUBLICATIONS

NEW YORK

*For Mother, with love*

Copyright ©1996 by Susan Rayfield
First Published in 1996 in the United States
by Watson-Guptill Publications,
a division of VNU Business Media, Inc.,
770 Broadway, New York, NY 10003
www.watsonguptill.com

Library of Congress Cataloging-in-Publication Data for this title can be obtained by writing to Library of Congress, Washington, DC.

Manufactured in Malaysia

ISBN 0-8230-5745-3

Senior Editor: Candace Raney
Associate Editor: Dale Ramsey
Designer: Howard P. Johnson, Communigrafix, New York
Production Manager: Hector Campbell

First paperback printing, 2000

3  4  5 / 04  03

SUSAN RAYFIELD is the author of six books, including *Wildlife Painting: Techniques of Modern Masters, Painting Birds,* and *Marine Painting,* all published by Watson-Guptill. A former picture editor for Audubon magazine, she was a creative force behind the Audubon Field Guide series.

In 1988, she judged the prestigious "Birds in Art" exhibition sponsored by the Leigh Yawkey Woodson Art Museum, in Wausau, Wisconsin, and in 1955 she was chosen to judge the sixteenth Annual International Show at the Mystic Maritime Museum, in Mystic, Connecticut. Ms. Rayfield lives on Buttermilk Cove, in Brunswick, Maine.

Cover image:
Daniel Smith, *African Ebony,* 1993, acrylic, 32" × 24" (81.3 × 61 cm).

Half-title image:
Carl Brenders, *The Family Tree,* 1995, gouache, 37$\frac{1}{2}$" × 23$\frac{1}{8}$" (95 × 58.8 cm).

Title page image:
Terry Isaac, *Call of Autumn,* 1995, acrylic, 15$\frac{1}{4}$" × 40" (38.7 × 101.6).

# ACKNOWLEDGMENTS

My deepest thanks to the artists of this book, whose generosity made the project possible. Thanks also to Mary Nygaard, of Mill Pond Press, Inc., Julie Helgren, of Lindart Inc., Midge Nelson, of Art Haven, Sarah Koller of Wild Wings, Inc., and Clive Kay, in Ontario, Canada, who put me in touch with Leigh Voigt.

I am also grateful to both Robert A. Kret, director of the Leigh Yawkey Woodson Art Museum in Wassau, Wisconsin, and Dan Gaarder, of *Wildlife Art News,* for supplying me withsome of the catalogs, magazines, and ideas that got this book underway. Pauline Fortin has my thanks for her help with transcribing the interviews.

Finally, my gratitude goes to Dale Ramsey, my editor at Watson-Guptill, for his skillful editing, to Howard P. Johnson, for his wonderful layout, and to Hector Campbell, for the quality of the printing. Finally, hearty thanks to M. Stephen Doherty, Editor-in-Chief of *American Artist* Magazine, for his engaging foreword, and to Candace Raney, Senior Acquisitions Editor, for her support and guidance from start to finish.

# CONTENTS

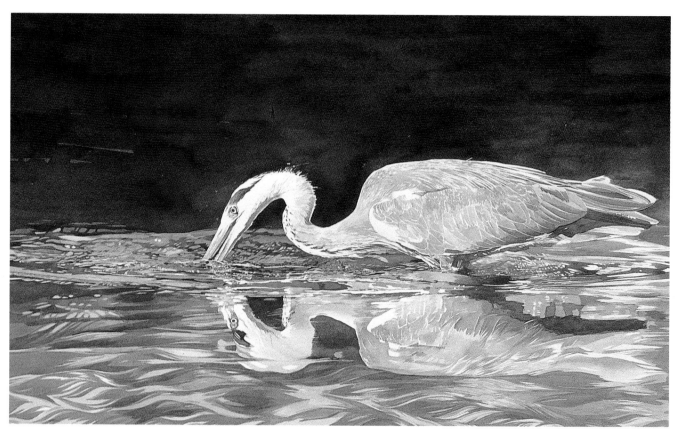

Leigh Voigt, *Grey Heron Fishing*, 1995, watercolor, 24″ × 36″ (61 × 91.4 cm).

# CREDITS

Cover: ©1993 by Daniel Smith. Courtesy of the artist and Mill Pond Press, Inc., Venice, Florida.

Half-title: ©1995 by Carl Brenders. Courtesy of the artist and Mill Pond Press, Inc., Venice, Florida.

Title page: ©1995 by Terry Isaac. Courtesy of the artist and Mill Pond Press, Inc., Venice, Florida.

pp. 10-11. Courtesy of John Seerey-Lester.

pp. 12-15. Courtesy of Art Haven.

pp. 16-17. Courtesy of Wild Wings, Inc.

pp. 18-19. Courtesy of Mill Pond Press, Inc., Venice, Florida.

pp. 20. Photo courtesy of Carl Brenders; sketches courtesy of Mill Pond Press, Inc., Venice, Florida.

p. 21. Courtesy of Mill Pond Press, Inc., Venice, Florida.

pp. 22-23. Courtesy of Carl Brenders.

pp. 24-29. Courtesy of Mill Pond Press, Inc., Venice, Florida.

p. 30. Sketch courtesy of Terry Isaac.

pp. 30-33. Courtesy of Mill Pond Press, Inc., Venice, Florida.

pp. 34-37. Courtesy of Leigh Voigt.

pp. 38-39. Courtesy of Mill Pond Press, Inc., Venice, Florida.

p. 39. Sketches courtesy of Terry Isaac.

pp. 40-41. Courtesy of Mill Pond Press, Inc., Venice, Florida.

p. 42-45. Courtesy of Art Haven.

pp. 46-47. Courtesy of Morten E. Solberg.

p. 48. Courtesy of Terry Isaac.

p. 49. Courtesy of Mill Pond Press, Inc., Venice, Florida.

pp. 50-55. Courtesy of Leigh Voigt.

pp. 56-57. Courtesy of Mill Pond Press, Inc., Venice, Florida.

p. 57. Sketches courtesy of Daniel Smith.

p. 58-59. Courtesy of Terry Isaac.

pp. 60-61. Courtesy of John Seerey-Lester.

pp. 62-63. Courtesy of Mill Pond Press, Inc., Venice, Florida.

p. 63. Courtesy of Daniel Smith.

pp. 64-65. Courtesy of John Seerey-Lester.

pp. 66-67. Courtesy of Wild Wings Inc.

pp. 68-73. Courtesy of John Seerey-Lester.

pp. 74-75. Courtesy of Dino Paravano.

pp. 76-77. Courtesy of Wild Wings Inc.

pp. 78-79. Courtesy of Morten E. Solberg.

pp. 80-81. Courtesy of John Seerey Lester.

pp. 82-83. Courtesy of Mill Pond Press, Inc., Venice, Florida.

pp. 84-89. Courtesy of Richard Sloan.

pp. 90-91. Courtesy of John Seerey-Lester.

pp. 92-97. Courtesy of Art Haven.

pp. 98-99. Courtesy of Richard Sloan.

pp. 100-101. Courtesy of Mill Pond Press, Inc., Venice, Florida.

p. 102. Courtesy of Daniel Smith.

p. 103. Courtesy of Mill Pond Press, Inc., Venice, Florida.

pp. 104-105. Courtesy of John Seerey-Lester.

pp. 106-107. Courtesy of Mill Pond Press, Inc., Venice, Florida.

pp. 108-109. Courtesy of Art Haven.

pp. 110-115. Courtesy of Morten E. Solberg.

p. 116-117. Courtesy of John Seerey-Lester.

pp. 118-119. Courtesy of Leigh Voigt.

pp. 120-123. Courtesy of Dino Paravano.

pp. 124-125. Courtesy of Mill Pond Press, Inc., Venice, Florida.

pp. 126-127. Courtesy of Carl Brenders.

pp. 128-131. Courtesy of John Seerey-Lester.

p. 134. Courtesy of Mill Pond Press, Inc., Venice, Florida.

p. 135. Courtesy of Art Haven.

p. 136. Courtesy of Mill Pond Press, Inc., Venice, Florida.

p. 137. Courtesy of Wild Wings Inc.

p. 138. Courtesy of Dino Paravano.

p. 139. Courtesy of John Seerey-Lester.

p. 140. Courtesy of Richard Sloan.

p. 141. Courtesy of Mill Pond Press, Inc., Venice, Florida.

p. 142. Courtesy of Morten E. Solberg.

p. 143. Courtesy of Leigh Voigt.

# FOREWORD
## M. Stephen Doherty

Editor-in-Chief, *American Artist Magazine*

Eight years ago I had an experience which convinced me that the process of becoming proficient at almost anything involves two basic principles: learning the fundamentals of the discipline, and gaining control of activity. I had that revelation when I put on a pair of skis for the first time and signed up for a beginner's lesson at a ski area near my home.

While the young man who gave me that lesson was a bit cocky and punctuated every sentence with the words "like" and "dude," by the end of the three-hour session he had given me advice that now makes it possible for me to ski expert slopes at almost any ski resort. In particular, he did two things that help me get better and better every time I take a run down a mountain. First, he taught me the fundamental skill of shifting my weight from one downhill inside edge to the next as I plant my ski poles and carve a swerving path down a mountain; and he explained that the challenge in skiing is not just to get down the incline, it is also to descend with style and control.

In a very real sense, those simple concepts—learning fundamentals and gaining control—can make the difference between an adequate wildlife painter and a great artist. Anyone can copy a photograph or an illustration in a magazine, just as anyone can slide down a snow-covered mountain on his or her backside. But to make a picture that stands as a well-composed, accurate, and expressive work of art, one has to handle the painting materials with understanding and precision.

Fortunately, the artists who share the secrets of their creative process in this book are more articulate than my ski instructor, and their demonstrations are more elaborate and detailed. Each person provides valuable information about the working properties of different painting media, the process of understanding how animals live, the need for environmental diligence, and the elements that lend individuality to a picture. Their advice is at once simple and profound, and you'll find yourself coming back to it over and over as you pursue your interest in wildlife art. You'll find yourself remembering Carl Brenders' advice about painting fur with multidirectional strokes, Daniel Smith's comments on making water bubbles look believable, and John Seerey-Lester's tips on creating atmosphere with layers of color and gesso.

But creating art is more than a process of conquering fundamental skills. At some point skiers develop a personal style that makes it easy to identify them as soon as they start down a hill, and an artist establishes a look that makes his or her paintings recognizable from across the gallery. There is something unique about their choice of subjects, compositions, palette of colors, and paint application that establishes their personal vision. And as obvious as that might be, the process of creating a style is one of the most difficult challenges an artist faces. More often than not, it happens after spending a considerer amount of time studying the work of other artists.

One should also be mindful of the kinds of activities which engage these artists when they are away from their easels. They travel to wildlife preserves, read books on animal behavior, make sketches of seasonal changes in habitats, consult with zoologists, and become active members of conservation groups. The artists learn as much as they can about their subjects so that their pictures tell stories which are accurate and engaging.

This book provides an opportunity to carefully analyze paintings, consider what you like about them, and determine how you can instill the same qualities in your own work. In short, it provides the inspiration for you to take on greater challenges as a wildlife artist yourself.

# FAMILY LIFE

*Carl Brenders*

*Alan M. Hunt*

*Terry Isaac*

*Lee Kromschroeder*

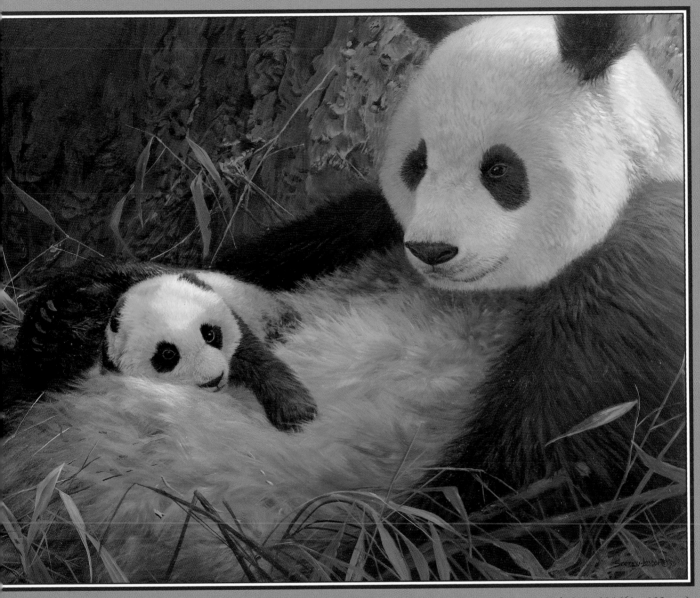

John Seerey-Lester, *Mo Tsi (Giant Panda with Young)*, 1995, mixed media on panel, 24″ × 30″ (61 × 122 cm).

# PAINTING STRIPES AND FUR DETAILS
*Alan M. Hunt*

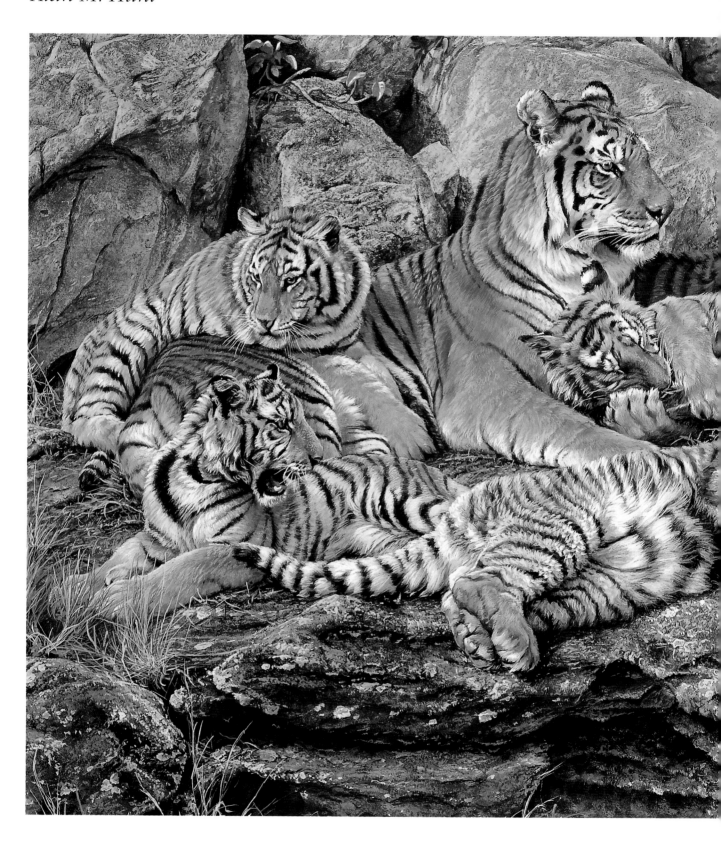

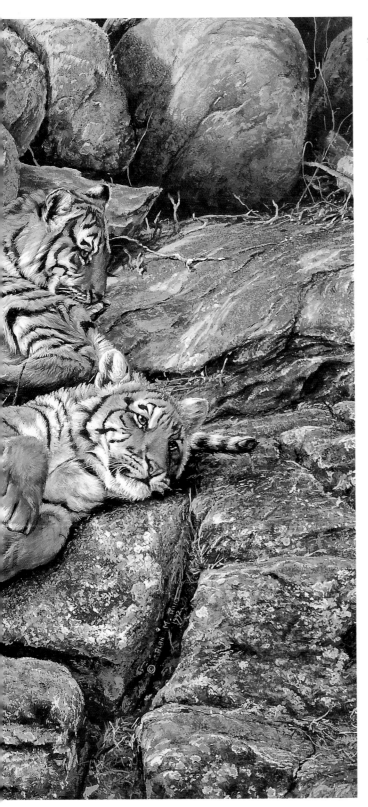

## RESTFUL INTERLUDE — TIGER FAMILY

*1992, gouache, 19¼" × 30" (49 × 76.2 cm).*

Taking advantage of gouache's facility for putting in fine detail, Alan Hunt used this opaque watercolor medium to paint a female tiger relaxing as her cubs settle on the warm rocks by their den. Unlike acrylic or oil, gouache doesn't clog the brush but flows easily with every stroke. Indeed, one of the problems with gouache, according to Hunt, is that you can't always get enough paint on the brush to do the job. He recommends sable brushes because they hold more water between the hairs.

Painting fur is not as difficult as it looks, says Hunt: "People think artists paint every single hair, but we don't. Ninety percent is done with a 1/2" or 1" flat brush. We fan the ends out and flick the tip of the brush along the surface, which creates the effect of hundreds of hairs at a time."

To paint convincing fur, Hunt focuses on the shadows created by the fur and on patterns of growth. Hair radiates from the animal's eyes and nose, curls down across the cheekbone, and again across the chest, where it swirls back on itself. It splits along the backbone and grows down the flanks and legs, swirling again behind the haunches. Wherever muscles bunch up or the skin folds, a shadow is created. The shadows, of course, define the animal's shape and form.

Stripes further define a tiger's contours. Just as the width and shape of each stripe vary as it flows over the body, its color changes, too. It helps to know that the hair within the stripe is actually a different type of fur. "It's almost in relief, and you've got to paint it that way," Hunt observes. The tigers' stripes are not black but rather a mix of burnt umber and ultramarine blue—more brown for warm touches and more blue for cool highlights. Where the black stripe meets the golden fur there is a slightly reflective light. The very edge of the gold area is a warmer burnt sienna, so a too-sharp demarcation between the two is avoided.

Hunt used thin washes of burnt umber, raw umber, burnt sienna, yellow ochre, and cadmium yellow to convey the rich variations in the reddish gold coats. Since gouache is easily damaged, he worked from the top down, and from background to foreground. Before stopping work he extended edges into areas "behind" those he planned to paint when he resumed.

In this way, *Restful Interlude—Tiger Family* was painted over several weeks, during which Hunt worked twelve to eighteen hours a day. The schedule sounds grueling, but, as he explains: "Professional wildlife artists do so much traveling and field work, and we attend so many exhibitions, that when we're in the studio we've got to be very disciplined just to complete our workload."

# Sketching Zoo Animals
## Alan M. Hunt

### Color Tiger Studies

*1990, various media, each sketch 7¾" × 10¾" (19.5 × 27 cm).*

Alan M. Hunt visits zoos to get a closer look at many of his subjects. For some color studies of a tigress and her cubs he visited England's famous Whipsnade Zoo.

Here, the artist loosened up with rapid, gestural drawings in pencil to get the family's relationship in size and scale. Sketches that looked promising received watercolor washes of raw sienna. Opposite (top), Hunt captures an affectionate moment between mother and cub. Below that, a cub plays in the grass, cupping a hindfoot in its big front paws.

Back at the studio, the artist gave one study a more finished treatment in gouache over watercolor to further explore anatomy, markings, color, and shade. Two years later, Hunt used these color studies and the pencil sketch, which he reversed, as the basis for *Restful Interlude — Tiger Family.*

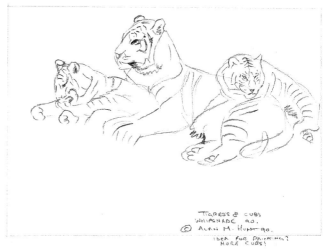

*Hunt's initial pencil sketch inspired his painting.*

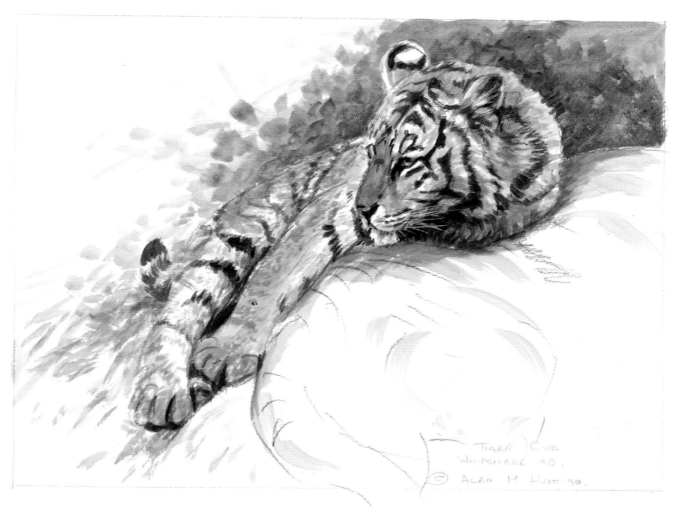

*A pencil sketch was further embellished with watercolor and gouache.*

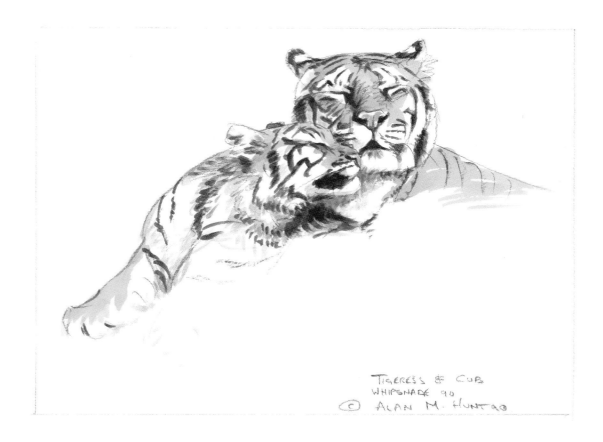

TIGRESS & CUB
WHIPSNADE 90
© ALAN M. HUNT 90

*Here, watercolor was applied*
*over Hunt's pencil sketches*
*(top and bottom).*

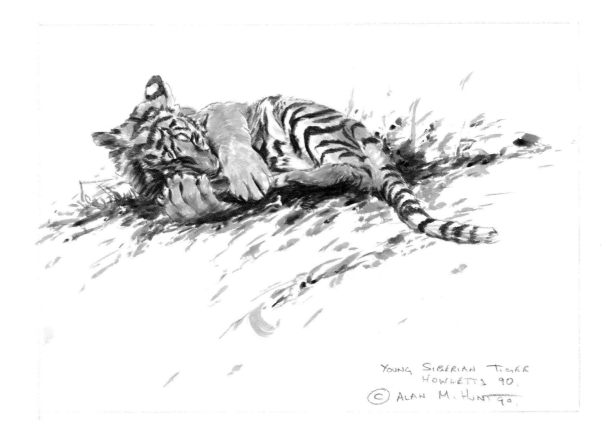

YOUNG SIBERIAN TIGER
HOWLETTS 90.
© ALAN M. HUNT 90.

# DESIGNING WITH COLOR
*Lee Kromschroeder*

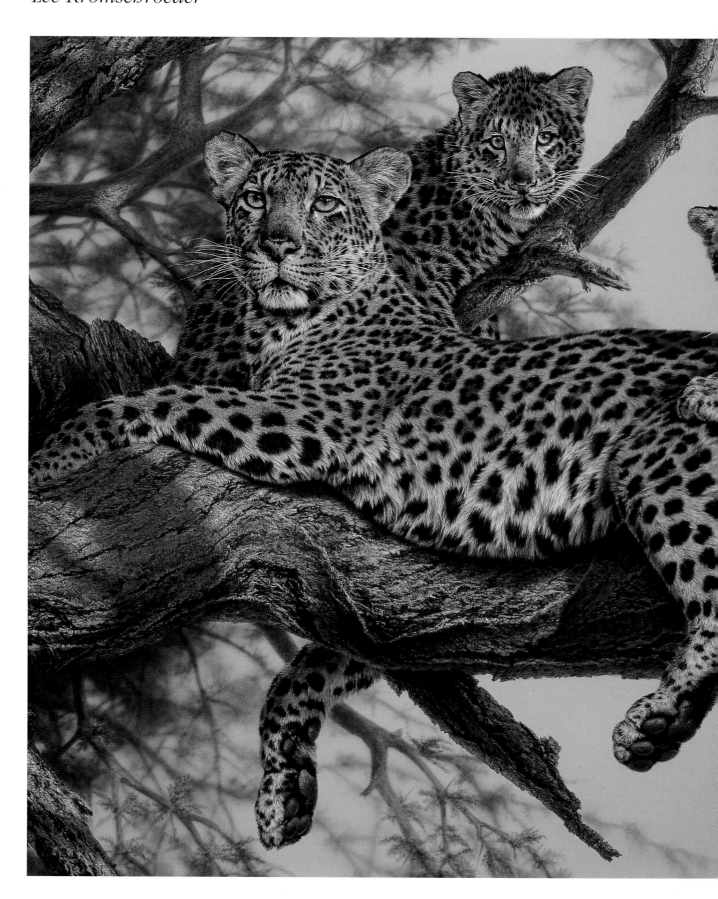

# FAMILY TREE

*1994, acrylic, 23" × 31" (58.4 × 78.7 cm).*

Some pictures begin with a vivid experience—in this case, seeing a leopard in a tree in Africa, at sunset, watching the breeze ruffle her soft belly fur, then hearing her hidden cubs in the grass below.

In the studio, the memory having percolated in the artist's mind for months, suddenly a design presents itself: Put the cubs in the tree with the mother, and call it *Family Tree*. Two months later, Lee Kromschroeder had a finished painting. In the meantime, he faced a struggle with composition, light, and color—issues even professional artists have to work through.

He first thumbnailed the trio, positioning the cubs above the female looking across at each other. This design proved too busy, and it would have meant increasing the size of the painting and adding more branches. "Reality check right there," Kromschroeder said. He tried pushing the cub on the right all the way down to Mom. That worked. He cropped its tail. Now the cub on the left was too high. He moved it down, behind the mother's head.

Instinctively, he was creating a classic composition—a triangle of heads within a circle of bodies. But what to do about the body crossing behind the mother's head, creating a confusion of spots and fur? Kromschroeder solved that problem by introducing light in the space between the two. "It's not a coincidence that there's a splash of light across the cub's face while, strangely, no light hits its body," he said.

The branches were used as stage props, leading the viewer's eye up, around, and down again.

When Kromschroeder settled down to paint he faced a color problem: how to bring out the golden sun on the female's belly, which was so vivid in his memory. According to color theory, purple is the complement of yellow; that is, it lies directly across from yellow on the color wheel. Put side by side, the two complements will reinforce each other. Thus Kromschroeder elected to paint the entire background a soft purple or gray. "Even if I had painted it a neutral gray, it would still look purpley," he remarked, "because a bright color [like the gold-yellow] will always 'push' a neutral color to look like the complement." The background acts as a "glue" that holds the whole picture together.

Over the background, he began laying in the female's spots and dark shadows as he began to define her shape. The rusty areas on her ears were done with thin washes of raw umber and burnt sienna, and raw umber goes across her back. The spots themselves are a true black for impact, painted painstakingly one after the other. Kromschroeder has some advice for those whose attention might begin to flag while painting such details: "Become that spot," he says. "Feel that spot as it wraps around the leg. Each spot done well increases your confidence to try more."

Up to this point the leopard looked muddy, with dark spots over the purple. Next came the creamy yellow on the belly and face, followed by highlights to indicate sheen. The pads of the feet were washed with red, then with blue to cool the red, and finally with raw umber to mute the red.

Kromschroeder has mixed feelings about the results. "As much as I like it, it will never be as great as standing there in the balmy African breeze looking at that leopard," he said. "On the other hand, I feel like shouting: 'Stop! Look at this wonderful creature!'"

# CREATING A COMPOSITE IMAGE
*Carl Brenders*

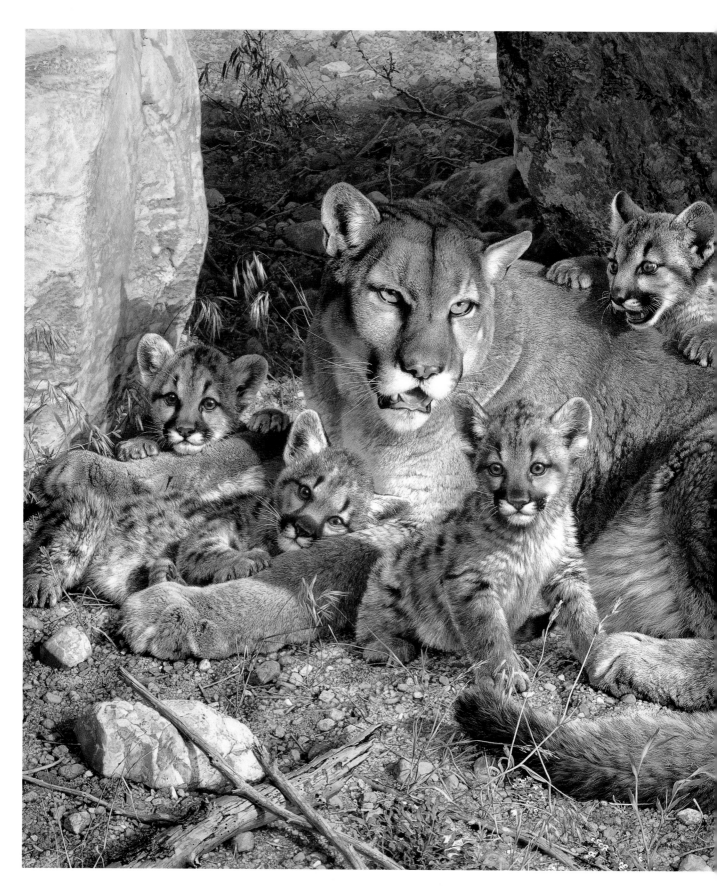

# ROCKY CAMP—COUGAR FAMILY

*1993, gouache, 27" × 36¾" (68.6 × 93 cm).*

"This painting is based on the nicest field work I ever did," comments Carl Brenders in his book *Wildlife: The Nature Paintings of Carl Brenders.* "For the first time in my career, I could control the situation. I had the painting already in my mind. I wanted rocks in the background. The only thing missing was a model for the texture of the fur in the light that I wanted. At a game farm in California, where they train animals for Hollywood movies, I got my best opportunity. There was a rocky place behind the farm where a docile, well-trained female cougar could lie down exactly where I wanted her—one couldn't dream of a better situation."

The picture was constructed from a number of images that Brenders gathered together—photos, studies, and so on. "After lots of sketches and tryouts for compositions, the painting was born," the artist says. "Three months of work—the longest time I ever spent on a painting."

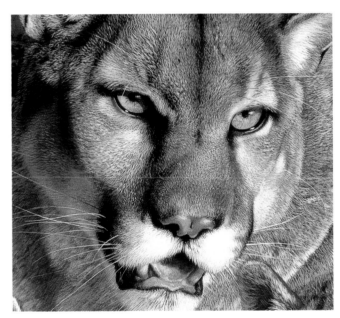

*The female cougar's eyes are painted green using gouache; warmer tones at the rim of the eyes are put in using watercolor. For her tongue and nose, the artist mixed white with burnt sienna gouache, then added a bit of carmine watercolor. Shadow areas were muted with neutral gray for a slightly bluish effect.*

# CREATING A COMPOSITE IMAGE

Before starting a painting, Carl Brenders makes numerous drawings of the animals to capture their expressions and make their distinctive movements familiar to his mind and hand. These studies of cougar cubs were incorporated into *Rocky Camp—Cougar Family* (page 18).

*Brenders assembled the final composition from a variety of photo references, taking the female cougar's head from one picture and her body from another. The cubs were drawn from yet another set of prints.*

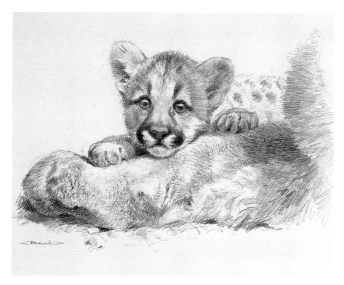

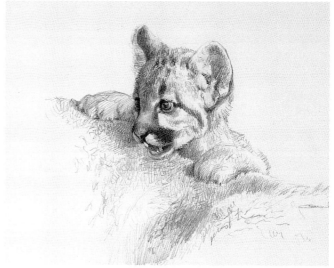

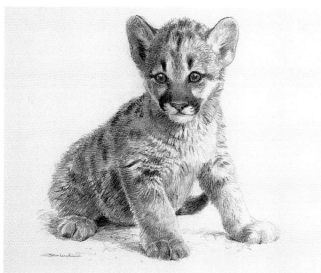

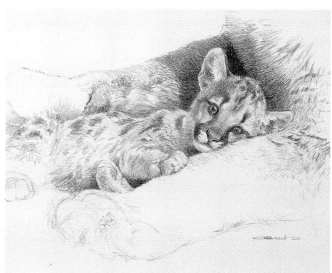

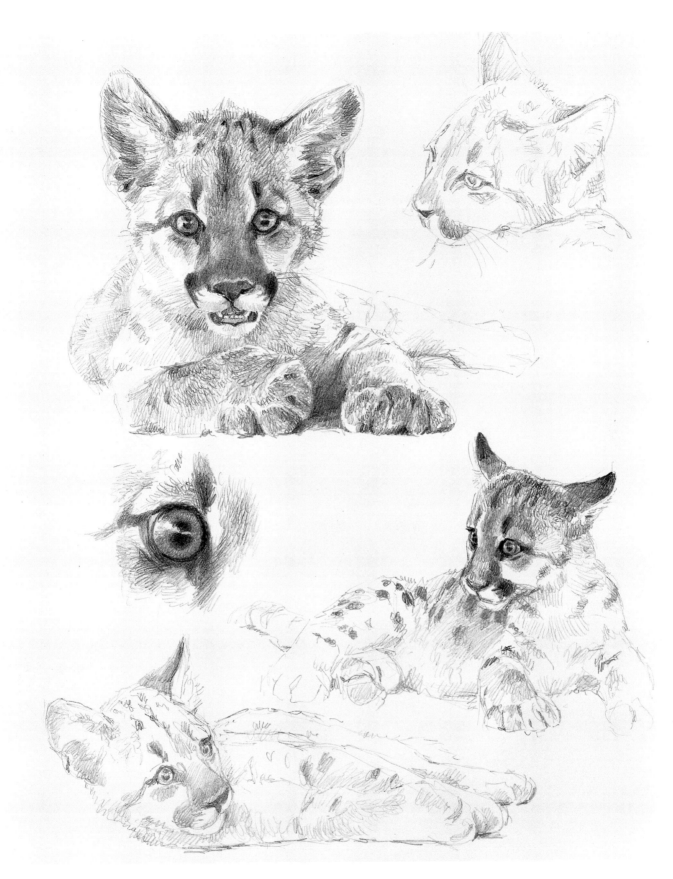

*"Just like children, cougar cubs all look different:*
*Their spots vary, sometimes very dark and pronounced,*
*sometimes vague and light," Brenders says. "Cougars*
*usually have three cubs but can have up to six.*
*I painted four to get a nicer composition."*

# Creating a Composite Image

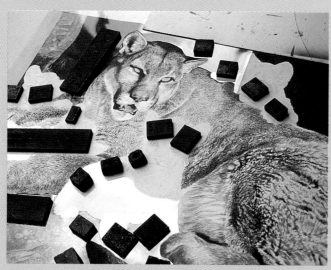

The female was drawn in sepia watercolor; cubs and background were masked with acetate to keep those drawings clean. Weights kept the acetate in place.

Watercolor was applied with an airbrush.

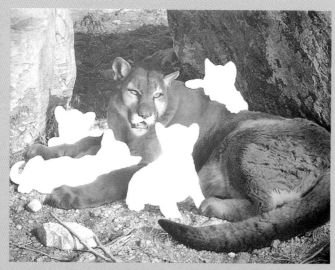

The acetate removed, Brenders began work on the mother cougar in gouache.

The pencil drawings were reinforced with dark sepia watercolor.

The female's fur was created by repeatedly painting tiny lines with the brush squashed down on the paper to splay the hairs. "That way you can make five or six hairs with one stroke," Brenders says. He strokes the brush in slightly different directions, taking up a bit more or a bit less paint depending on whether the fur is dense or loose. The rust-colored area on her shoulder consists of cadmium yellow deep overpainted with brown watercolor here and there for texture. The cubs' spots were painted in sepia watercolor.

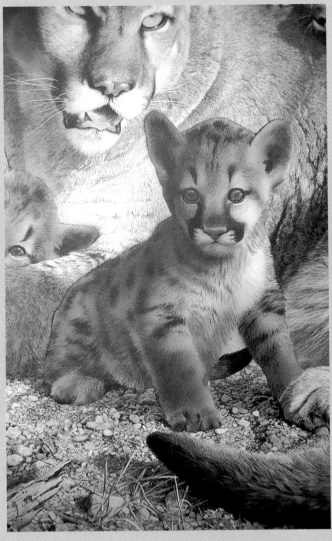

*The cubs were airbrushed in watercolor.*

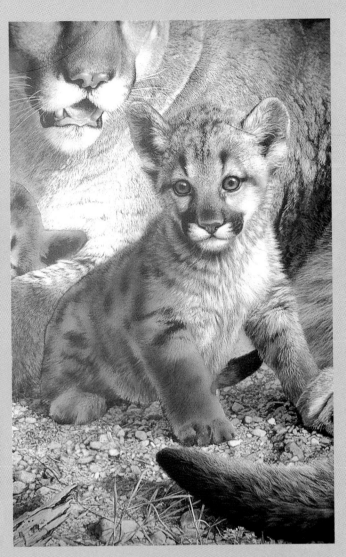

*Fur details were laid in over the airbrush work using gouache.*

*Small details painstakingly put down one next to the other create fur, as shown in this detail. "Going from one side to the other, you are putting in thousands and thousands of little lines," the artist explains. The hind leg has been airbrushed; the tail has received gouache details.*

# WORKING WITH GRAYS AND EARTH COLORS
*Carl Brenders*

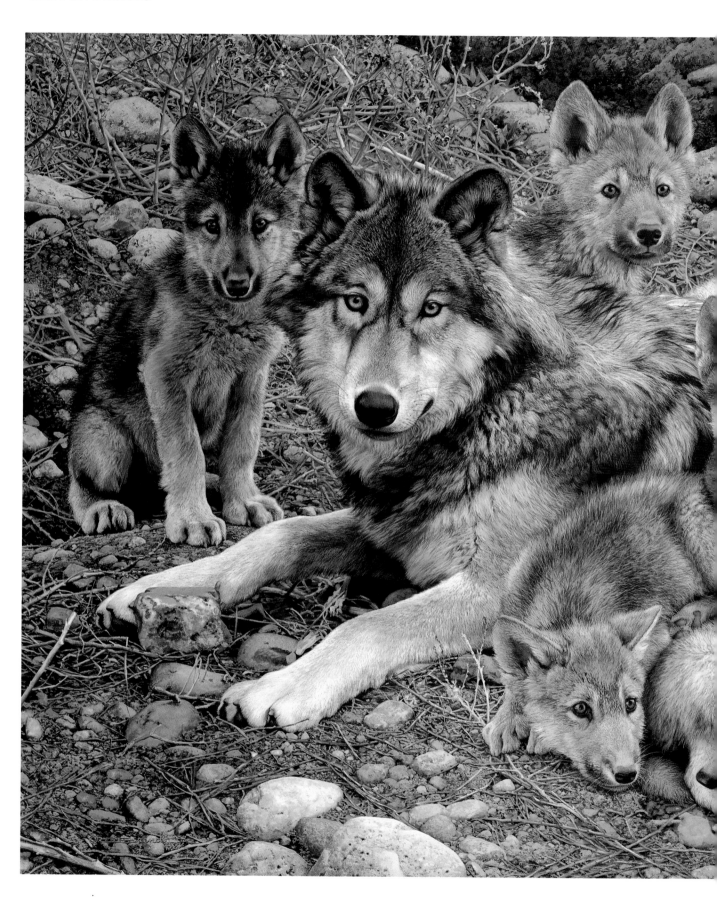

# Den Mother—Wolf Family

*1992, mixed media, 26⅛" × 31⅝" (66.3 × 93 cm).*

Wolves are special to Carl Brenders, who considers them the symbol of wilderness. "The eyes of a wolf are the most magnificent things you can imagine," he says. "They have all the wilds of the northern hemisphere in that glance."

*Den Mother—Wolf Family* is the second in a series of wildlife family portraits. To research the painting, the artist spent some time with a not-so-tame privately-owned wolf in a secluded setting. The pups were photographed later, at a game farm in California. "They were like wonderful little dogs," Brenders recalls. "You could pet them. You could take them on your knees."

He took pictures from all angles, in the shade and in the sun, so that when he returned to his studio and combined the images with those of the mother he could make the light direction for each animal match. "That is what you need to make such a composite," Brenders says. "Having the same source of light is very important, to make it believable."

Working over a sepia watercolor drawing on illustration board, the artist painted the wolves in gouache and watercolor, drawing with the paint. The darkest fur is pure sepia watercolor, applied almost opaque. Brenders combined Talens gray gouache No. 2 and No. 4 to neutralize yellow ochre and raw umber, which gave him the brown on the pup's heads and chests. "You get a really soft brownish color if you add yellow ochre or umber to that gray," he said.

The reddish-brown vegetation in the background, done with burnt sienna gouache, provided a pleasing contrast to the gray-brown coloration of the animals.

The prospect of painting fur daunts many artists, but not Brenders, who always chose the fur coat ads when illustrating catalogs years ago. He got the complex look of fur by breaking some of the finely rendered hairs with opaque watercolor over the gouache, and by having them go in a slightly different direction.

The wolves, as with most of Brender's subjects, regard the viewer as an intruder. "I think that is natural," Brenders comments. "We have nothing to do with the wild, and we should stay out. A wild animal never likes you to be there. You are a threat to its territory. You are a threat to its young. They do not like you, actually. That is why they look like that."

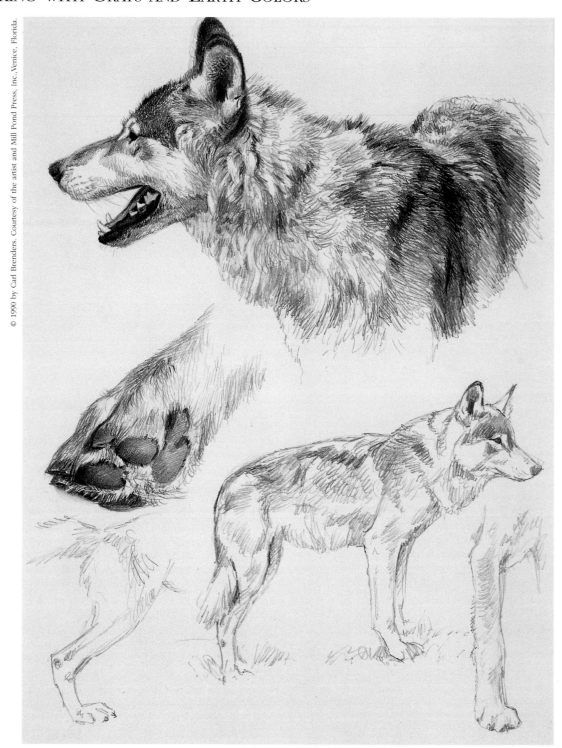

*Wolf Study*, 1990, pencil on paper, 13¾″ × 10⅛″ (35 × 25.8 cm).

Before he starts paintings such as his wildlife family portraits, Carl Brenders makes many careful pencil renderings of his subjects, drawing them over and over again until they penetrate his mind. "Their proportions, their expressions, the teeth, the tongue, the eyes—all these things you have to carefully study," he advises.

The basis of most of his paintings is field work, which he does on gallery tours and visits to game farms and zoos. The artist also does a lot of hiking and backpacking with a camera, returning with up to fifty rolls of film. Since 1983, he has spent part of every autumn in Yellowstone National Park.

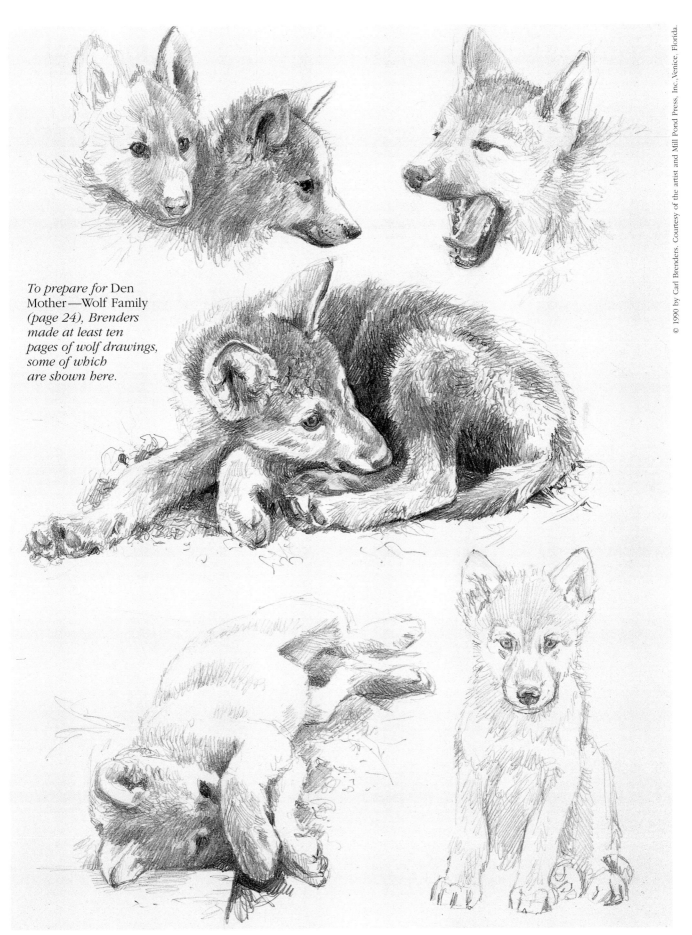

*To prepare for* Den Mother—Wolf Family *(page 24), Brenders made at least ten pages of wolf drawings, some of which are shown here.*

*Wolf Study,* 1990, pencil on paper, 13¾″ × 10⅛″ (35 × 25.8 cm).

# ALTERNATING GOUACHE AND WATERCOLOR
*Carl Brenders*

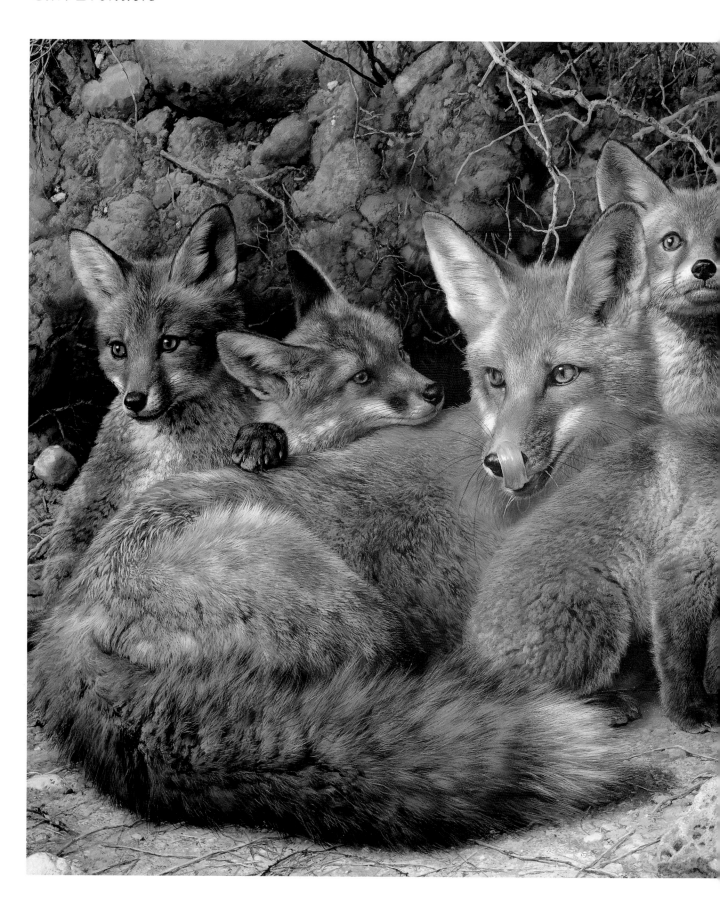

# FULL HOUSE—FOX FAMILY

*1989, gouache, 24⅞" × 35" (63 × 89 cm).*

*Full House —Fox Family* didn't start out as a family portrait. In the preliminary sketch of four young foxes, one looked more like an adult, so the artist decided to make it a mother. He added two more kits and created a family.

Brenders builds his paintings in three layers: watercolor, gouache, then watercolor again. By alternating the two, he avoids a too-thick buildup of gouache, which would crack and flake off. He is able to combine the mediums by carefully controlling the water in his brush so that the paint flow is minimal. "I work with very little water in my paint," he says. "This is very important. You have to practice a lot to know how much water you need for the effect you want. Too much water will result in sharp edges when the paint dries, which I do not want." Artists who use too much water will find the gouache lifting up when they paint over it, and the result will be mud. Just a little water, with as few layers as possible, does the trick.

He applies his first layer of watercolor with an airbrush, transparently, over the sepia watercolor drawing. At this point, "it looks a bit like a gummy cover," says the artist. "It's not realistic. The animal looks like a rubber toy."

Fur details are "drawn" on using gouache. Here, the colors of the fur range from white with yellow ochre to cadmium yellow deep, deep sienna, and dark brown. If used transparently, gouache on top of dark watercolor can look chalky: "There is always some white in gouache, and on a dark-colored base it turns a bit bluish, which gives a chalky effect," Brenders explains. He suggests that in areas where you wish to compensate for this effect, make the color on your palette more yellowish or more ochre than you think you want it. The bluish effect can be used to advantage: "If I want a blue sheen on the back of a dark animal, I do it with transparent white gouache. If I don't want that, I add yellow ochre or another warm color, to avoid the blue effect."

Final details, like whiskers and some of the hairs in the fur, were drawn with a very fine brush using watercolor over the gouache.

When the painting was finished, Brenders thought the face of the mother fox needed something more, so he added her tongue.

# INTEGRATING SUBJECT AND BACKGROUND
*Terry Isaac*

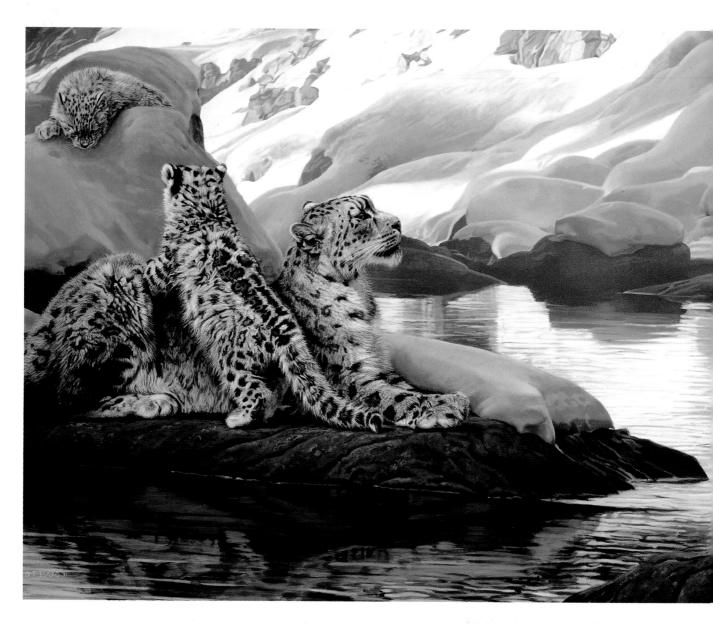

© 1991 by Terry Isaac. Courtesy of the artist and Mill Pond Press, Inc.,Venice, Florida.

*Isaac often does up to ten thumbnails to work out compositional problems, calling them "variations on a theme." Here, the sphinx-like pose of the mother snow leopard anchored the scene.*

# WATCHFUL EYE—SNOW LEOPARDS

*1991, acrylic, 17½" × 36" (44.5 × 91.4 cm).*

"It isn't easy being a mother, especially when you have three at once," says Terry Isaac. "I found the setting of this painting, with its traversing horizontals of rock, water, and snow, an immensely interesting composition. The variety of natural textures and values appealed to me. I placed a mature snow leopard, with her bold maternal eye, in repose to echo the sweep of the landscape." The setting is actually borrowed from a mountain site near Lake Tahoe, in California.

Using the female as the focal point, Isaac created an oval design around the water shape. The curve of the upright cub's tail is repeated in the curve of the mother's front leg and the clump of snow to create a sweeping line. Her outstretched paw points to the cub at the far right, and the strong edge of the background snowbank pulls the eye back to her again. The interplay between the two cubs on the left creates a diversion that keeps the painting animated.

Isaac laid in the background loosely, then painted the cats. To unify subject and background, he brought the blue of the snow and brown of the rocks into the animals' fur. Working light and dark, he built up the medium-value fur by concentrating on one area at a time. He referred to an isolated small section of his value sketch (see opposite) and then painted the corresponding section of the Masonite on which he was working. His darkest darks were a mixture of Payne's gray and burnt umber, with varying values of gray throughout the fur, and his warm darks were raw sienna and raw umber, with a bit of ultramarine blue where the fur reflects the sky. Highlights were done with titanium white.

Individual hairs were laid on with a Richeson Series 9000, No. 3 watercolor brush. "Each strand of hair was a brushstroke, but underneath that was the basic value and color that you see," the artist says. The effect of deep fur can be achieved by layering the paint, building light fur on top of a darker base. If it starts looking too contrasty, Isaac uses a wide brush to glaze the whole area with a transparent gray or brown wash to blend. The fur on the standing cub represents up to ten such layers of glazing. Fine details were added with a 00 brush.

Toward the end of the artist's work, the background had become too dominant and needed to be pushed back to enhance the sense of depth. Isaac masked the mother and nearby cubs and then airbrushed the snow with a pale mix of Payne's gray and titanium white. Bright snow highlights were "picked out" in white.

# LENDING COLOR RICHNESS TO WHITES
*Carl Brenders*

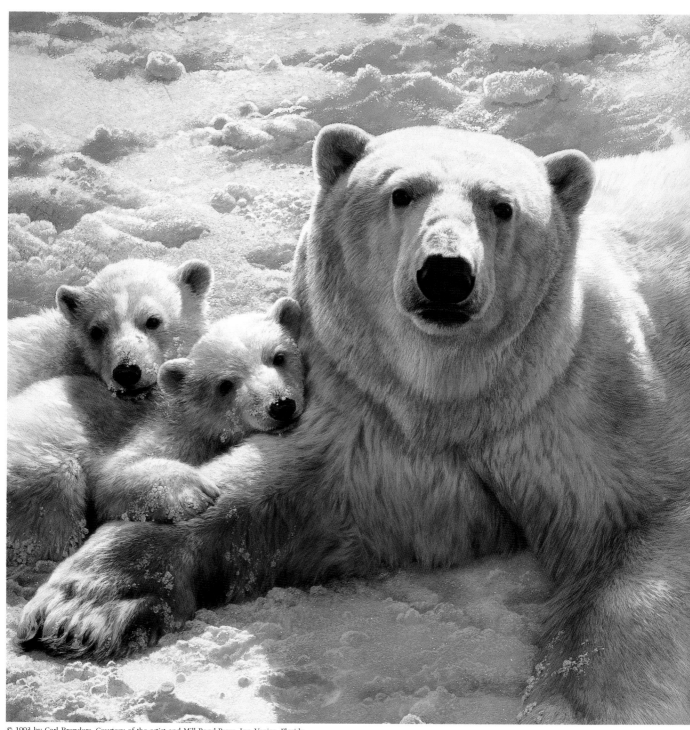

© 1993 by Carl Brenders. Courtesy of the artist and Mill Pond Press, Inc.,Venice, Florida.

# MOTHER OF PEARLS

*1993, gouache, 27½" × 38¾" (70 × 98 cm).*

"Polar bear cubs are beautiful little creatures," says Carl Brenders. "Their fur is incredibly soft, and with the northern sunlight on it lots of nice reflections appear on the fine hairs — like the reflections of pearls. I was surprised that these white animals can be so colorful in the snow. Most polar bears are not white at all. I got so excited about their creamy color, combined with the sky's blue reflections on the snow, that I could not wait any longer to make this painting, although so many other subjects were waiting." The painting was the result of field work in Churchill, a Canadian town near the Arctic Circle where the polar bears live close to people.

The skin of the bears is black, Brenders notes. Their hairs are translucent and hollow. "It gives the effect of white, but it's not really white. It is a very strange thing. You have to know that to paint it well." The fur actually glows with color, and besides white and neutral gray, he uses yellow ochre, cadmium orange, and touches of ultramarine blue. The snow is colorful too: light gray with yellow ochre in the sunlight, and light gray with ultramarine blue in the shadows.

Brenders does not hesitate to enhance a hue to achieve a certain effect. "To paint you need colors," he says. "As an artist you are allowed to exaggerate. That is what I did in this case."

Although he explains his technique clearly, Brenders' extraordinary detail finally comes down to innate talent. "You feel the fur in your mind, your soul, and all of your body," he says. "It comes out because you want to get that fur. You feel the animal, you feel the muscles. You feel how the fur fits over those muscles when they move. You have to pay attention to the direction of the hairs — which way they go, and then they move this way and so on. You know that the fur on the shoulder will break open and you can look into it. You paint that a darker color."

The only way to bring the huge polar bear into the foreground was to crop the image. "In my paintings I like to be really close to the animals," Brenders explains. "In *Mother of Pearls* I wanted to have the feeling of being part of that family, close to that big, soft, wild mother."

*Brenders made many drawings of polar bear cubs to capture their juvenile look. One evolved into this small color study.*

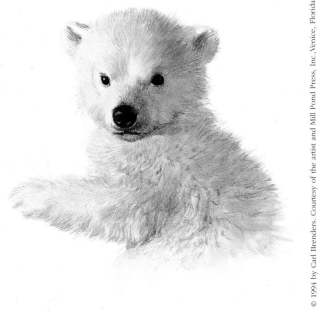

*Polar Bear Cub Study,* 1994, mixed media, 4" × 6" (10.2 × 15.2 cm).

# HIGH BRANCHES
# AND
# BACKYARDS

*Alan M. Hunt*

*Terry Isaac*

*John Seerey-Lester*

*Daniel Smith*

*Morton E. Solberg*

*Leigh Voigt*

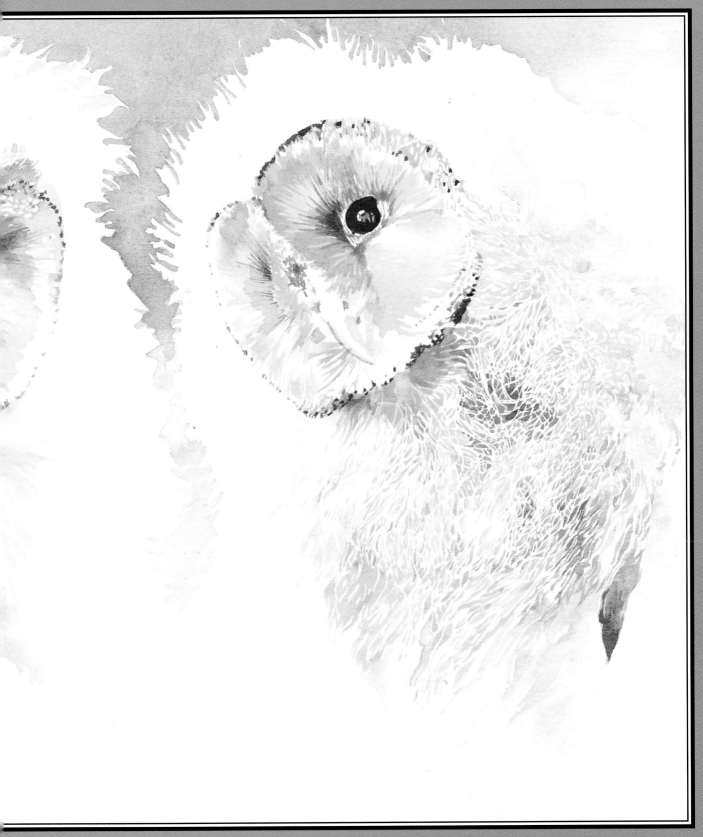

Leigh Voigt, *Baby Owls,* 1995, mixed media on panel, 24″ x 30″ (61 x 122 cm).

# Exploiting the Immediacy of Watercolor
*Leigh Voigt*

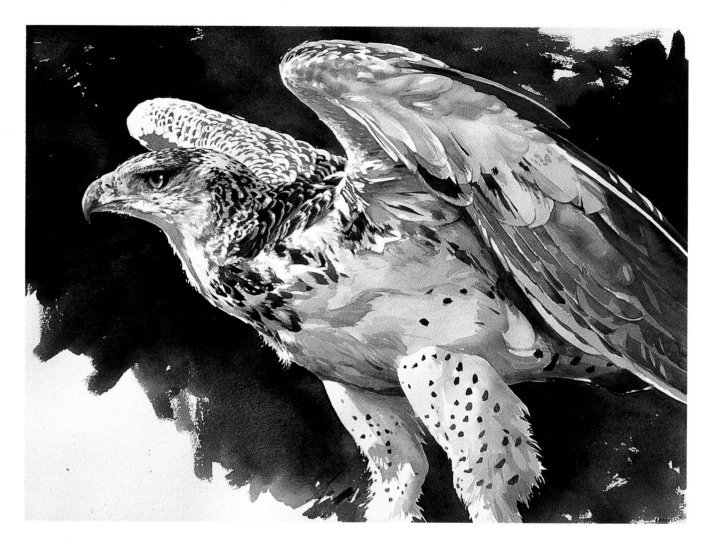

## Martial Eagles

*1995, watercolor, 22" × 30" (56 × 76.2 cm).*

"Watercolor suits me because it is immediate, fresh, and quick," says Leigh Voigt. There is no room for tentative dabbing, insouciant washes, or muddy colors. While it's not always possible to rectify a misplaced brushstroke, so the act of placing a mark or wash must be a carefully considered step, it's just as important to recognize the value of a happy accident or an unplanned puddle of paint. "Once I feel I have captured the essence of a subject and recorded details — such as a wayward feather, a pattern, a glint in the eye — I let the paint take over," Voigt says.

Here, she blocked in the darkest areas first to establish contrast early on. Then she built the eagle's form with soft washes. She regularly examined her reference material, which ranges from her own color slides, bird skins, or frozen birds she keeps in her freezer, to live subjects either at zoos or privately owned, as was the case here. Everything about the way Voigt works is sparing, including her palette — just a few colors on a white dinner

plate, plus two glasses of water: one getting dirty, the other kept clean.

Voigt is a purist who never uses masking fluid, tape, or white paint. The results with those materials appear too slick, she thinks. She uses Winsor & Newton tube colors and the finest sable brushes. She reports going through a lot of Series 16, size 00, and a few Series 16, Nos. 4, 8, and 11. In what may seem sacrilege, she nips a millimeter off the tip of each new brush, so that it doesn't leave a little comma when she's working in fine detail. "Most people want a very sharp point to their brush, but I like a little flat edge to it," she explains. "It's got a little bit of stubbiness to it, which gives a more sensitive line."

Voigt works quickly and tries to stop at exactly the right point. "If I don't, I usually end up throwing the painting away," she says. "Too much detail becomes tedious, both for me and the viewer, whereas capturing the essence is *Te Deum,* an exultation. One in a hundred. A little background Beethoven also helps."

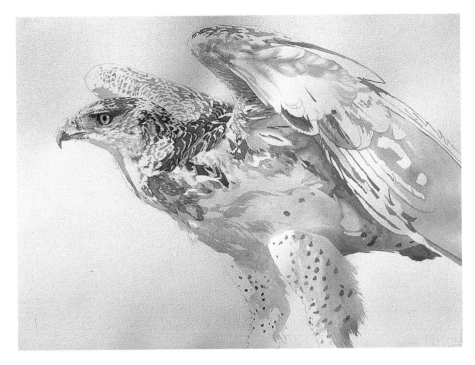

*After careful, very light penciling, Voigt first painted the dark shapes, giving immediate form to the subject and establishing the light source. "Wildlife subjects should be bathed in sunlight, with rich deep shadows," she asserts.*

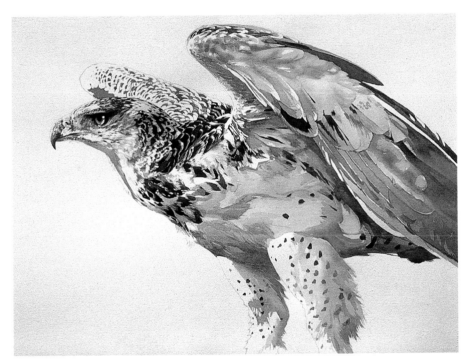

*Colors were further strengthened, from the darkest, a Van Dyke brown mixed with cobalt, to the softest, a mix of cerulean blue, raw sienna, and brown madder alizarin. In the finished image (opposite), a diagonal background wash was added, and corners were left white. The bird itself retains a fresh spontaneous feeling. "What you leave out is as important as what you put in," Voigt says.*

*Voigt's advice for drawing wildlife is to keep the pencil point sharp, keep turning it, and concentrate as you go. "You must never let your hand get lazy and start thinking of something else."*

# Depicting a Familiar Bird with a Fresh Eye
*Terry Isaac*

## Backyard Robin

*1992, acrylic, 23½" × 24" (32 × 61 cm).*

Terry Isaac has traveled from Costa Rica to Canada, but his favorite wildlife subjects are right in his Oregon backyard. Here, he enlivened a common sight—a robin in spring—by capturing it in sunlight perched in a flowering dogwood. "I also enjoyed the complementary color scheme — the red of the robin's breast and the green of the foliage, punctuated by the white of the blossoms," he observes. Exploring color and light, he avoided the ordinary and made the familiar fresh.

He first sketched the birds he saw and made up a few robin cutouts of different sizes. He then traced the one that looked best onto Masonite, using white graphite paper. Isaac primes his boards with six coats of Grumbacher gesso, sanding every second coat to create an ultra-smooth surface.

First, Isaac laid in an overall wash of raw umber, Payne's gray, and ultramarine for a warm middle tone. He painted the foliage in light greens on top of darks with a worn-out, dry brush. For texture, he scrubbed the paint on in a circular fashion, working quickly to avoid a hard edge. The artist's favorite foliage colors are chromium oxide green and permanent Hooker's green toned down with raw umber, burnt umber, and Payne's gray. The oxide in particular is "a very natural-looking green," Isaac says, "not too blue, not too yellow." Highlights were made with Hansa yellow light and a vivid lime green, with a bit of titanium white added in the lightest passages. The blossoms are a combination of whites, blues, and greens, with yellow glazed on top. Where sunlight hits the blossom on the left, Isaac outlined the dark central stamens with yellow to give them a three-dimensional look.

Starting with a white outline, the robin was painted using a Richeson No. 4 flat brush. Thinking of the robin's breast as egg-shaped, Isaac carefully considered how he would model it using dark and light colors, reflective light, and shadow. The breast color is a mix of burnt sienna and Payne's gray. Its sun-struck side has a yellow ochre, cadmium red, and white highlight. Thin washes of cadmium green here and there pull the foliage color into the bird, and bits of "robin red" can be seen among the blossoms, unifying subject with background.

Feathers were indicated with several strong W shapes using a Richeson No. 4 round brush. The robin's head and wings are Payne's gray highlighted with titanium white. The eye is a blend of Payne's gray, ultramarine, and burnt umber, with a pure white highlight to reflect the sky. The beak is yellow ochre and titanium white, with burnt umber added for the shadow. Beneath the robin's breast, Isaac added a green "bounce light," a glow of light reflected from the foliage on its underside. The shadow side of the bird is the same value as the dark background. This loses the edge and avoids a cutout look.

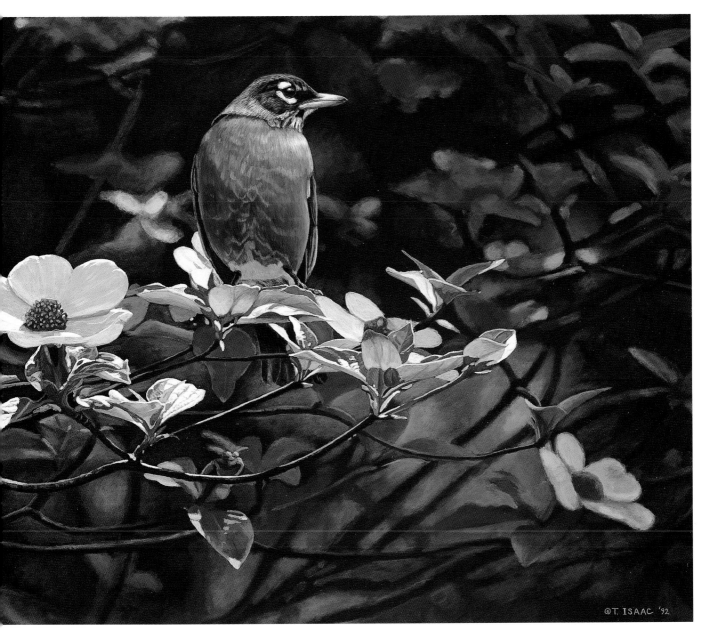

©T. ISAAC '92

# PAINTING AN OWL FROM CAREFUL OBSERVATION
*Alan M. Hunt*

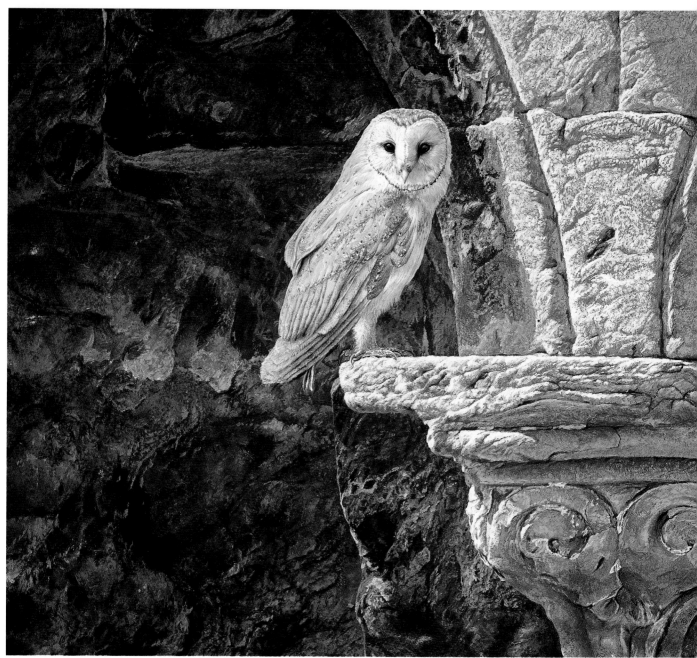

# Ancient Glow—European Barn Owl

*1992, acrylic, 20" x 30" (51 x 76.2 cm).*

Eerie shrieks haunt the nights around Alan Hunt's farm in rural England, and by day pale specters float over the grass. Actually, barn owls inhabit the ruins of an eleventh-century abbey in the valley below. "Most ghost stories are about barn owls," the artist says. "You see this ghostly creature floating through a churchyard, with its horrible screams, and you might well imagine that you've been visited by a dead ancestor."

To portray an owl correctly, the artist must know its physical characteristics. Studying the barn owl, Hunt focused on its overall plumage pattern rather than individual feathers. Owl feathers, unlike those of other birds, do not lie flat in layers but intermingle vertically, like fur. The edges of the flight feathers are serrated, locking like Velcro to form a baffle when the wing is brought down, which results in soundless flight. The plumage has a velvety matte finish, with no reflective gloss or sheen. Thus, individual feather edges, with the exception of wings and tail, cannot be seen and shouldn't be painted.

Hunt began this barn owl with a wash of pale yellow ochre, which he interfused with burnt umber, burnt sienna, and raw sienna. Feathers were delineated by their pattern; points and streaks of white and dark brown. The shadow color, consisting of ultramarine blue and burnt umber, was glazed over the top of the buffy white breast. Only the eyes are jet black.

The abbey's soft gold sandstone makes a perfect foil for the bird. Stone can be intimidating to paint, but Hunt let the paint itself do most of the work. Using a three-inch house-painting brush, he rapidly blocked in large areas of earthy midtones, letting the random surface suggest texture. An even quicker way to paint rocks, used by many professional wildlife artists, is to crumple a piece of paper, dip it into a puddle of paint, and press it over the background tones. The paper's edges create cracks and fissures in an instant. Old paint rollers and cellophane achieve similar results. After adjusting darks and lights, one can go back in with a dry brush and drag paint over the surface for texture.

The heart-shaped face of the barn owl makes it particularly appealing to paint. This one's face is echoed in the curves of the weathered carving directly beneath its feet. Light and dark variations in the background balance the simple and direct treatment of the bird, whose front-and-center position, in full sunlight, gives it power and intensity.

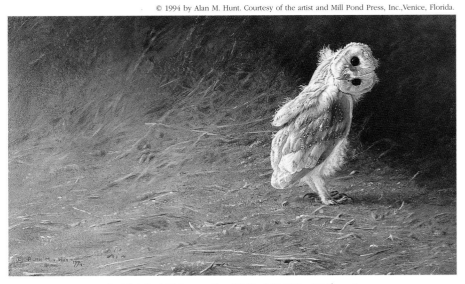

*This three-week-old barn owl had such funny mannerisms that Hunt named it Baldrick, after a comic character on British television. "Baldrick tried to look at everything in as many ways as possible: backwards, sideways, and upside-down. All the while, he bobbed up and down, trying to focus properly on the subject. He was a real character," the artist said.*

*Baldrick,* 1994, acrylic, 8½" x 14" (22 x 35.6 cm).

# Painting an Owl from Careful Observation

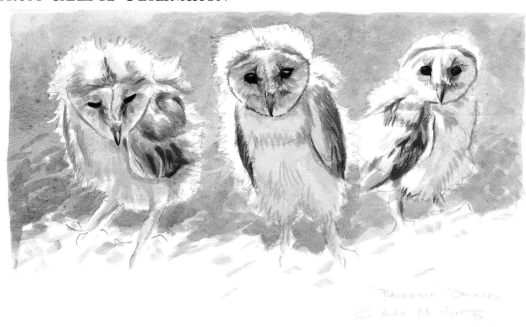

In this study the artist explored light and shadow. Note how the color of the owl's white breast varies, ranging from a yellow with blue shadows (left) to a blue tint with brown shadows (right). This study, done in minutes, consists of color washes over pencil.

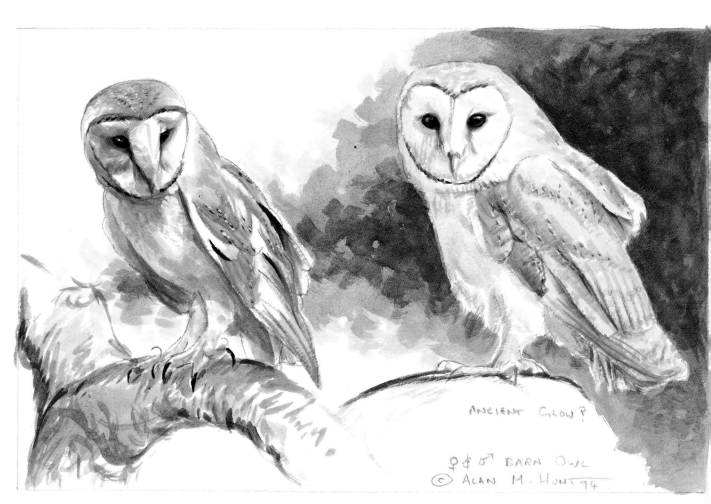

*The owl on the right, reversed, became the model for* Ancient Glow — European Barn Owl.

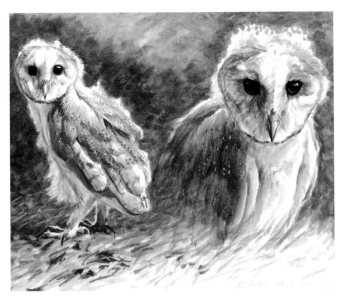

## Color Owl Studies

*1994–1995, mixed media, each 7¼" × 10¾" (18.5 × 30 cm).*

Inspiration for the paintings on the preceding pages came from artist–naturalist Alan Hunt's notebooks, which are filled with color studies like these. Made quickly in watercolor and gouache, the loose studies—consisting of color washes over pencil sketches—are meant to capture particular features of the bird or other animal, work out color gradations, and fully acquaint the artist with his subject.

Hunt made several quick portraits of Baldrick, a young barn owl he raised after it had been abandoned.

*Here, Hunt played with sidelighting and strong contrasts on the form of an adult barn owl.*

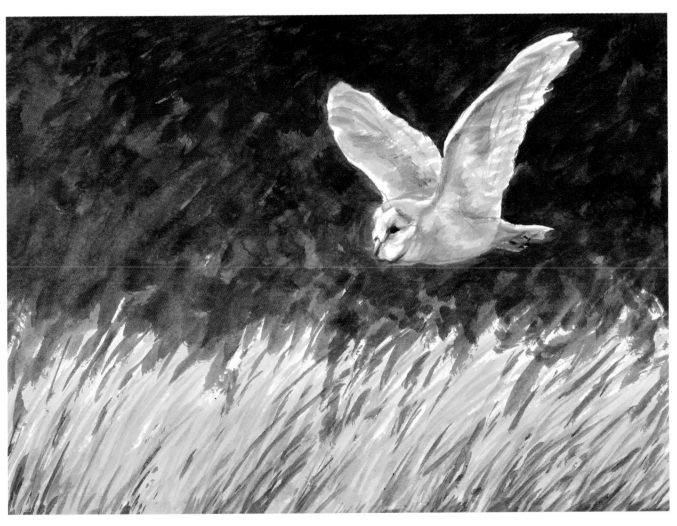

*A male barn owl — smaller, lighter colored, and rounder in the face than the female — flies over a field. The grass and the bird are close in value, bringing them forward against the dark background.*

# EMPHASIZING AN EAGLE'S STRIKING QUALITIES
*Alan M. Hunt*

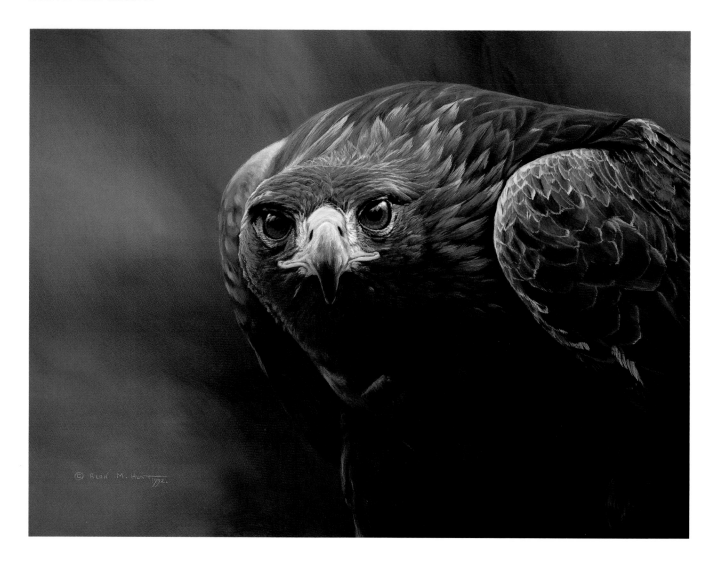

## MAGNIFICENT

*1993, gouache, 14¾" × 20⅛" (37 × 51.3 cm).*

Eagles convey fierce power and intensity. To capture these qualities, Alan Hunt placed their heads centrally and emphasized their eyes and beaks, the traits that most distinguish them.

An eagle's vision is the keenest in the animal kingdom, capable of spotting a rabbit a mile and a half away. "If you can capture that riveting stare, you're more than halfway there," Hunt says. Eagles get their fierce expression particularly from their prominent brow ridge, which shields their eyes from glare as they pursue their prey. Light enters the eye through the top or side, and exits after being reflected from the back wall. The highlight is always at the point where light hits the surface of the eye. The illumination from within is always at the bottom, where the color is warmest. "If painted expertly, you can see a mini-landscape in the reflection," says Hunt.

To suggest the dark, shiny surface of their strong beaks, he used an ultramarine wash, adding more and more white in glazes, finishing with a pure white highlight on the top. The way the beak sets into the head is important. If the gape (the soft yellow corner of the beak) isn't right, it's easy to turn the eagle into a caricature. "You don't want the bird to appear to be laughing or sneering," Hunt advises. "It needs careful observation."

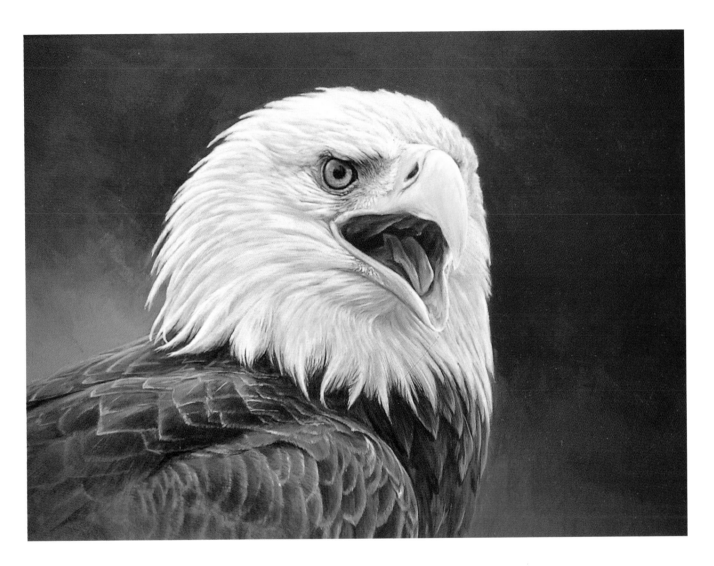

## BALD EAGLE

*1994, acrylic, 10" × 13" (25.4 × 33 cm).*

The shadows on the dark bodies of both birds are a mixture of burnt umber and ultramarine. The feathers—made by fanning a 1" flat brush and dragging it across the surface—are burnt umber and burnt sienna, with yellow ochre, burnt sienna, and white used on the very lightest ones. Highlights are a glaze of white, with a touch of ultramarine and crimson. For the shadows on the bald eagle's head, Hunt used only pastel glazes such as pale blue, lilac, or orange, depending on the source of the reflected highlights and shadows. "Anything heavier looks muddy and unreal," he notes. When painting in acrylics, he uses gesso instead of white. "It gives a more opaque, even base to glaze over."

The backgrounds were done as washes of complementary colors brushed on quickly and roughly. The colors around the beak and eyes were made slightly darker, to add to the impact of those striking features. "This sort of background implies there is something there," says Hunt, "without my having to paint anything definite."

# SOFTENING EDGES TO CONVEY MOTION
*Morten E. Solberg*

## SPRING NECTAR

*1994, watercolor, 14" × 30" (35.6 × 76.2 cm).*

*Spring Nectar* started out as a floral demonstration in one of Mort Solberg's workshops. "I got into it and realized I had something nice going, and I brought it home," the artist said. He cut eight inches off the top and added two rufous hummingbirds, which blend in with the bouquet.

Solberg started the painting at the right with exuberant splashes of red and yellow for the blossoms. He worked the shapes and outside edges upward and to the left. Loops of lines later became stems. The secret to painting florals in watercolor is to keep edges soft: "With soft edges you can slowly build and work in the darks. If you have hard edges, you can't go in and correct," Solberg says. He softens the edges by drybrushing. "As I put the paint on, I blend it off and let it run into whatever is behind it, or I bring in a dark color and then blend it out, so that it doesn't look cut out."

The last step was to define the yellow flower in the center in acrylic and add the birds, which he also painted in acrylic. Solberg drew their outlines onto tracing paper, then moved the cutouts around on the board until he found the right positions. Working from color prints, he filled in the body color and worked on the wings until they conveyed motion.

*To create the illusion of the hummingbirds' rapidly beating wings, Solberg laid some color at the tips and then wiped it off until there was just a blur. Closer to the body, where there is less motion, the wing color becomes darker.*

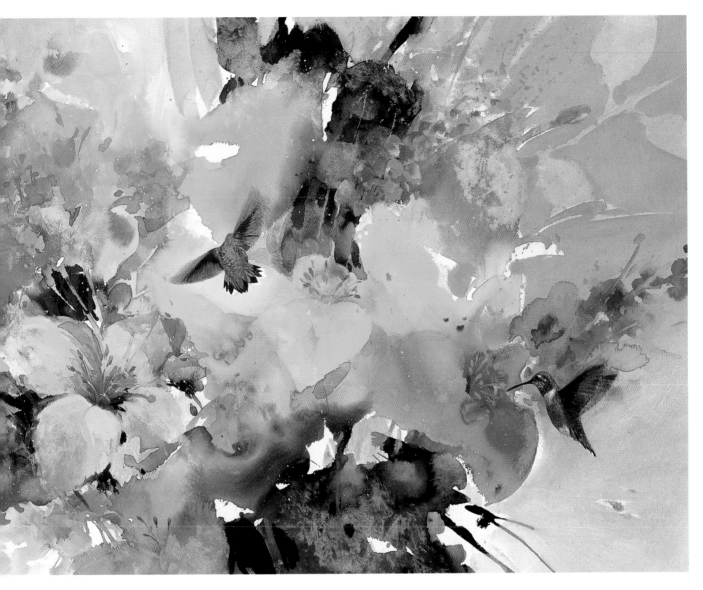

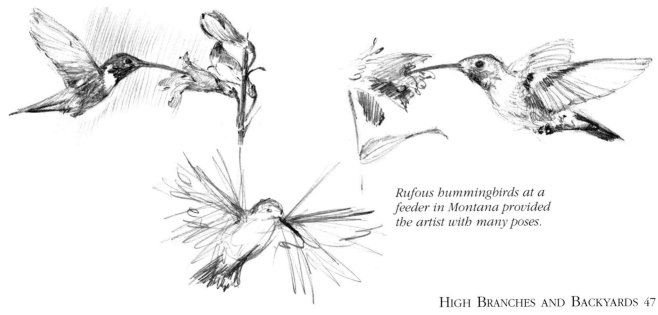

*Rufous hummingbirds at a feeder in Montana provided the artist with many poses.*

# BACKLIGHTING FOR DRAMATIC EFFECT
*Terry Isaac*

*Isaac makes thumbnail sketches to work out the size and position of the subject in the setting. Here, he considered an 11½" x 24" horizontal before deciding on the vertical format.*

## INTO THE LIGHT—TRUMPETER SWAN

*1991, acrylic, 15½" x 10¼" (39 x 26 cm).*

If you want to add drama to a painting, backlight the subject, as Terry Isaac has done here. Backlighting allows for the introduction of a strong, bright rim of light around a colorfully shadowed subject. Here, Isaac infused the shadowy form of this swan with yellow, pink, red, violet, and blue. Still, it reads as a white bird. Once he established the range, the artist used the same colors in different combinations throughout the painting to unify it.

*Into the Light* started with an overall undercoating in a medium blue, and this was graded to a darker value of Payne's gray and burnt umber at the top of the image.

The bird was drawn onto the finished background. "I was attracted to the silhouette of the swan, which made interesting negative shapes," Isaac says. The animation of the outstretched wings intrigued him too, as did the sparkle on the water. The sparkles were stippled on, then glazed over with titanium white to pull them together. Where several dots are isolated, just below the right wing, the artist painted pale violet halos, for an iridescent effect. The telegraphic lines in the water are cerulean blue, mixed with titanium white.

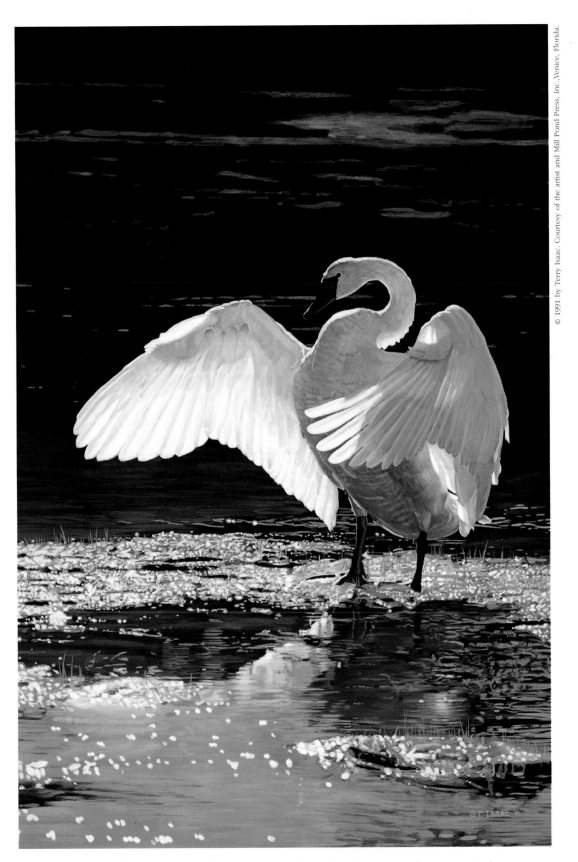

*Note the glowing color effects in the shadows. On the swan's chest a neutral gray mixed with ultramarine blue and cerulean blue was overwashed with a pinkish flesh tone on the wings; on the deeply shadowed side of the bird's head Isaac introduced yellow. The shadow areas on the predominately white wings were tinged with pink, violet, and yellow ochre, then glazed overall with a unifying transparent white.*

HIGH BRANCHES AND BACKYARDS 49

# PAINTING WITH A LIMITED PALETTE
*Leigh Voigt*

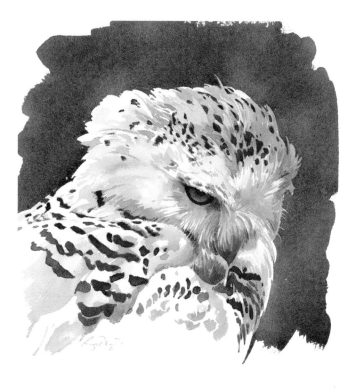

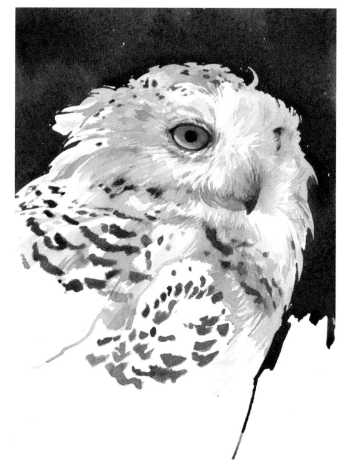

## SNOWY OWLS

*1995, watercolor, 14" × 30" (35.6 × 76.2 cm).*

When I saw these birds, I was astonished by their mysterious, almost eerie beauty. Their eyes have an impenetrable depth," says Leigh Voigt, who observed these snowy owls for the first time at a South African zoo. Since then, using a limited palette of earth colors for a dramatic range of lights and darks, she has painted them many times.

The owls shown here were "carved" out of the dark background, which was painted first with loose brushwork. The artist applied a broad olive-brown wash composed of raw umber, cobalt blue, and a bit of alizarin brown madder. In leaving the white outline of the owl she allowed for the random feathers that stick out.

The owls were painted with painstaking detail. Voigt is always intrigued by their intricate patterning. The darkest areas—the rim around the eyes and the plumage—were laid in first with a mixture of Van Dyke brown and cobalt blue, the closest color to black she ever uses.

Voigt put in her most intense color, chrome lemon yellow, for the riveting yellow eyes, dropping in some subduing raw sienna while the paper was still damp. "The eyes are very important," she says. "If I've got the eyes looking bright and alive, then I know the painting is going to work. But if I have to rework to get the sparkle, I might as well throw the painting away." The soft earth color on the owl's face is a mixture of raw sienna, cerulean blue, and alizarin brown madder.

To get the pattern right, she followed exactly the spots and stripes on her reference photo. She used a Winsor & Newton No. 4 round sable, flattening it against the paper and giving each shape a gentle sweep, from thin to thick.

The owls' form was built up with soft, whitish shadows made from her mixture of raw sienna, cerulean blue, and alizarin brown madder, now greatly thinned down. "This is a very light color, and you keep going over it on shadow areas." Voigt explains.

To add texture, she touched a drop of watery cerulean blue to the background wash here and there, while it was still damp, taking advantage of the pigment's granular quality. This technique is illustrated also in her study of a feather, opposite. "Cerulean and raw umber don't mix, like vinegar and oil," she says. After she added the blue, she tilted the paper so the colors ran away from each other like iron filings on a magnet. "It's lovely to play with paint like that," Voigt attests. "You almost forget that you're painting a bird and concentrate on the paint itself."

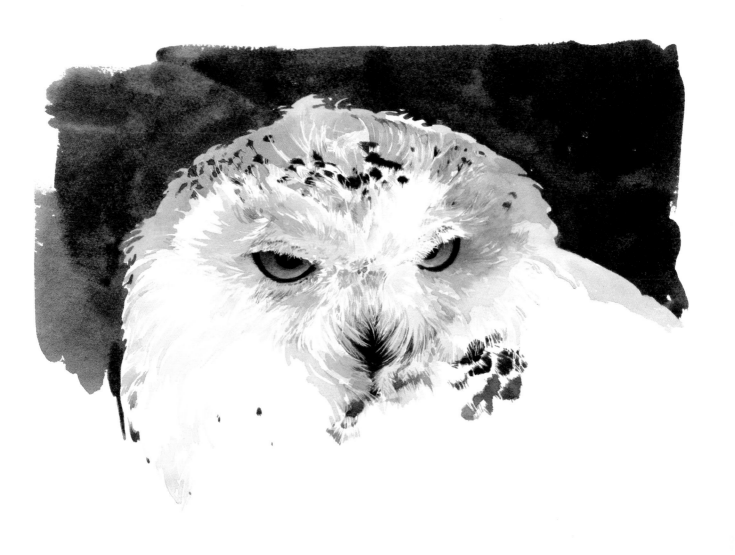

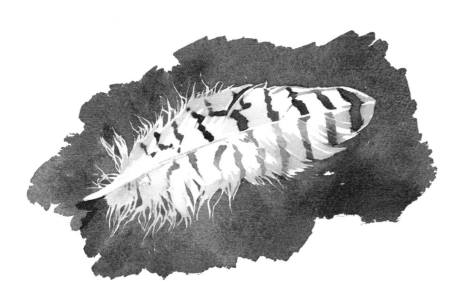

*To get the soft, appealing interplay of color in the background, Voigt added cerulean blue to a still-damp base of raw umber and tilted the paper.*

# Capturing Spontaneity in Watercolor
*Leigh Voigt*

## Fish Eagle

*1986, watercolor, 13" × 8" (33 × 20.3 cm).*

Because the essence of watercolor is spontaneity, Leigh Voigt aims at painting her pieces quickly, with strength and confidence, determining from the outset exactly what she wants to do. Here, she took pleasure in capturing the character of an African fish eagle and also in exploiting the expressive qualities of water on a rich paper surface.

The shape of the eagle, its feathers blowing in the wind like a mane, is defined by the bold background wash of brown madder alizarin, burnt sienna, and cobalt blue. Voigt painted quickly and loosely, letting flecks of the white paper show through to give the background energy. She laid in the darks with confidence, knowing they were going to stay as painted with no additional work. "I used a few quick brushstrokes, and that was that," she says.

Single washes, rather than layers of color, enhanced the picture's spontaneity. The belly feathers were put in with a deep red consisting of brown madder alizarin and raw sienna. Feathers on the white head and chest were indicated very lightly with a mixture of cerulean blue, raw sienna, and alizarin brown madder in equal proportions. The leading edge of the wing was a wash of Van Dyke brown.

Voigt painted the eagle on Arches 300 watercolor paper, which she doesn't pre-stretch, preferring to let it buckle. "The wavy quality gives a vibrancy to the color," she explains. "The paint puddles up in places. If I stretch the paper, it becomes flat and rigid, and the paint doesn't want to move at all." If she went too dark in an area, she knew the paper was heavy enough for her to throw on more water with a big brush and mop up the excess paint with cotton balls.

Completed in an afternoon, *Fish Eagle* was done not so much for the bird's sake, but for the sheer pleasure of the paint itself. "I could have been painting an old boot, it was so much fun. I used the density of the paper and paint well. It has quite a nice richness to it," says Voigt. Knowing instinctively when to stop was also a help. "You get to the point where you can't do one more brushstroke, otherwise you'll spoil it."

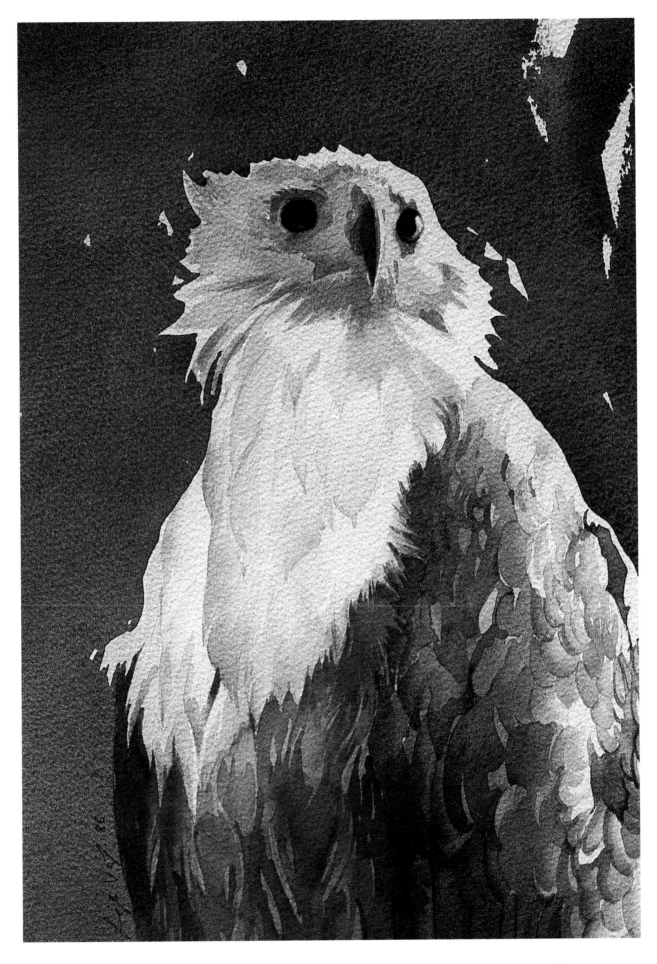

# PAINTING WHITE ON WHITE
*Leigh Voigt*

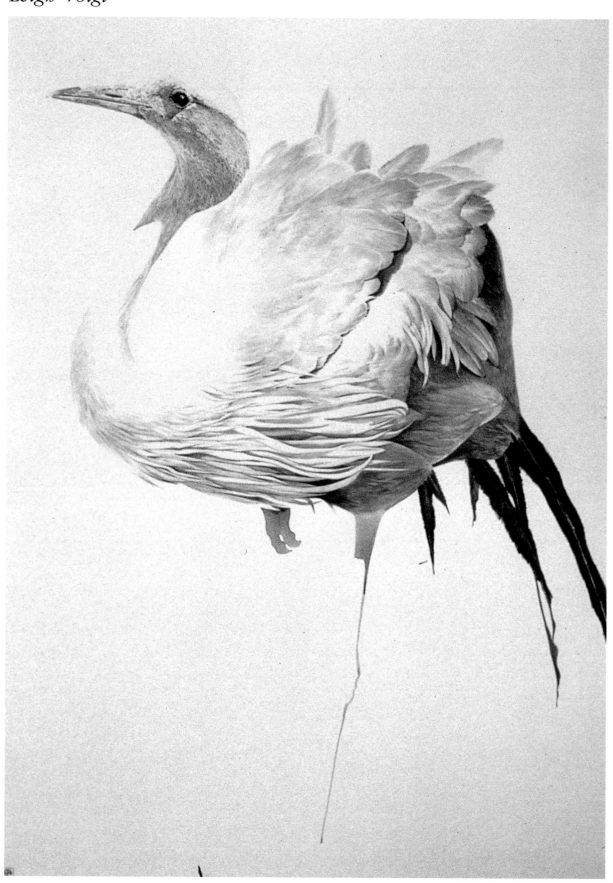

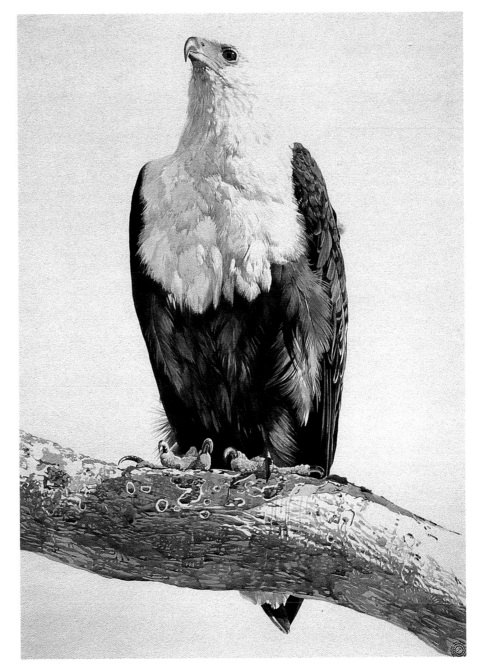

*When you paint white on white, the viewer's eye will complete the shapes. One side of this eagle's head is defined and the other is not, yet a complete head is apparent. "It's strange how you can see the white head against the white paper. You can feel its form, even if there is no demarcation between bird and sky," notes Voigt.*

*Fish Eagle,* 1987, watercolor, 29" x 20" (73.6 x 50.8 cm).

## BLUE CRANE

*1987, watercolor, 29" x 20" (73.6 x 50.8 cm).*

"I love painting white on white," says Leigh Voigt, who has been known to paint white flowers in white vases against a white background. "When you look at a white bird, you don't actually see the shadows until you have to paint them."

Here, an African blue crane stands serenely on one leg, its form defined by shadows. Voigt was attracted to the decorative qualities of this bird, which is actually not white at all but — as its name implies — blue. "I wanted to get that lovely line to it, the way its feathers arch, the roundness of its body, its long graceful neck and long legs. It's really the most wonderful bird," she says.

The crane seems to float on the page, tethered to an edge by a single tail feather. Its shadow color, which Voigt uses for all white objects, is a varying pale mix of cerulean blue, raw sienna, and brown madder alizarin in equal parts. The painting has a spontaneous feeling, more because of its restraint than lack of detail. "There are huge areas I left out, where I didn't touch the paper, and I didn't wipe anything away," says Voigt. One thing she is pleased not to paint are birds' feet.

Watercolor demands the lightest of light touches. The crane was painted on Schoeller Hammer board because its nonabsorbent surface allowed for more control.

# USING COMPLEMENTS IN A MUTED COLOR SCHEME
*Daniel Smith*

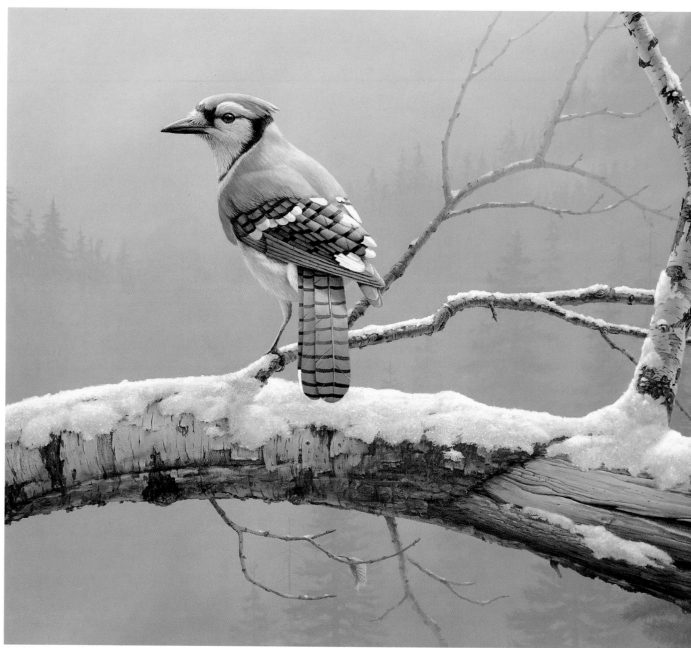

# WINTER SENTINEL—BLUE JAY

*1985, acrylic, 15" × 24" (38.1 × 61 cm).*

Muted blue-greens, and purples are mated with their complements to give this portrait of a blue jay its appeal. Because complements enhance each other, juxtaposing subdued versions of them allowed artist Dan Smith to preserve a colorful effect even though grayed-down shades predominate.

Smith primed a Masonite board with three coats of gesso, using a paint roller to get a fine-grained texture suitable for drybrush technique. Then he painted the background a uniform blue-green consisting of ultramarine blue, Payne's gray, phthalo blue, Hooker's green, and some yellow ochre. To be safe, the artist mixed four variations of this blue-green and stored them away. "For every painting I've got local colors saved, so I always have more on hand in case I want to paint something out," he says. "Some of these colors are difficult to arrive at." He also mixes these colors with those of the layers to follow, such as the blue of the jay, to integrate the subject with the background.

Smith built the painting from the background forward, plane upon plane. He added more Payne's gray and ultramarine blue to the background mix to create the fir trees in the mist, and then introduced a warmer orange on the birch branches to introduce the complement and to bring them forward (as a rule, warm colors seem to advance toward the viewer).

Thinly glazed over the complex background shade, the color of the jay goes from ultramarine blue, on its crest and shoulder, to phthalo blue, on its wings and tail, which have ultramarine shadows. The bird's back was warmed by some yellow ochre and raw sienna.

The sheen on the bird consists of titanium white mixed with blue and applied opaquely. If the color became too chalky, Smith glazed over it with a color unadulterated with white.

The jay's body feathers are soft and downy, while the wing and tail feathers have a crisper look. A slight irregularity in the tail feathers keeps the bird from looking Disney-perfect. The jay's pose is unusual in that it represents three different planes: head turned to the left, body at a slant, and tail facing the viewer. "It's important to pick a pose that isn't static. He looks alert, like he could fly off," the artist says.

Three licks of orange, in the form of autumn leaves, provide a complementary contrast to the blues — and the final touch enlivening this wintry scene.

*Smith sketched the blue jay in various positions as it perched on his backyard feeder.*

# Working from Photographs
*Terry Isaac*

*Snapshots taken on a hike became references for* Fall Foragers. *Here, a glowing oak leaf caught in lichen-covered twigs became the setting for* Fall Foragers — Black-Capped Chickadees.

## FALL FORAGERS—BLACK-CAPPED CHICKADEES

*1987, acrylic, 10½" × 7" (61 × 38.1 cm).*

Wildlife paintings come from many different sources, real and invented. Terry Isaac combines the two in composite paintings, using a subject from one place, and the background from another. This portrait of chickadees was put together from six different photos taken by the artist.

The process starts with field work—in this case, a November hike in the woods of his native Oregon. Inspiration came, as usual, with light—the afternoon sun beaming through a brilliant orange oak leaf. "It reminded me of a stained-glass window," Isaac recalls. He snapped a picture of the scene. Chickadees were calling all around. Later, he decided that the neutral-colored birds tinged with an orange buff color would be a good foil for the leaf.

Isaac prefers using his own reference photos to buying those taken by professionals because they trigger his memories of firsthand experiences—an essential ingredient in his creative process. "In essence, when I take a photograph, I'm really composing," he explains. "I'm envisioning how I may use certain elements of a scene in a painting."

He arranged his reference material and made as many as ten thumbnails, striving for a balanced and natural-looking composition. To have the light on the birds consistent with the leaf, Isaac had to depart from the light direction in his bird photos from front to back. "You're going to have to do some inventing, and that's part of the challenge," the artist says. Otherwise, the subjects look cut out and glued on.

# COMPOSING WITH CAMOUFLAGE PATTERNS
*John Seerey-Lester*

## EARLY ARRIVALS—SNOW BUNTINGS

*1985, oil, 9" × 12" (23 × 30.5 cm).*

Like black and white confetti, a flock of snow buntings swirls out of the sky to land on the tundra. They have arrived on their breeding grounds while there is still snow. The pattern of the melting snow against the dark, moist earth provides them with a near-perfect camouflage.

John Seerey-Lester saw this group—three males and a female—during a spring visit to Alaska. He noticed some movement and got out his binoculars, but had to search before he spotted them. The brown-colored female was the hardest to see. "I thought, well, that's the way I should paint them," the artist says.

He designed the background first, using stones and pebbles to break up the snow in a pattern similar to the darks and lights of the birds. The buntings were placed at the edge of the snowbank, the way the artist remembered seeing them. Then the process became a matter of further blending and breaking up forms and colors.

The pitch of the slope and the birds' bodies flow in the same direction—with the exception of one bunting sitting crosswise, which throws the viewer off a bit. The size and shape of the stones echoes the rounded form of the buntings, while scattered dark pebbles mimic their eyes. Even their lavender shadow color blends the blue of the snow with the brown in the rocks. Intermittent weeds add yet more visual complexity.

"What I put in behind the birds, and beside the birds, was very deliberate," Seerey-Lester says. "I kept going back and reworking the areas, putting things in or taking things out. It became a balancing act. I didn't want the birds to be obvious, and I didn't want them to completely disappear into the scene." Knowing when to stop was the key.

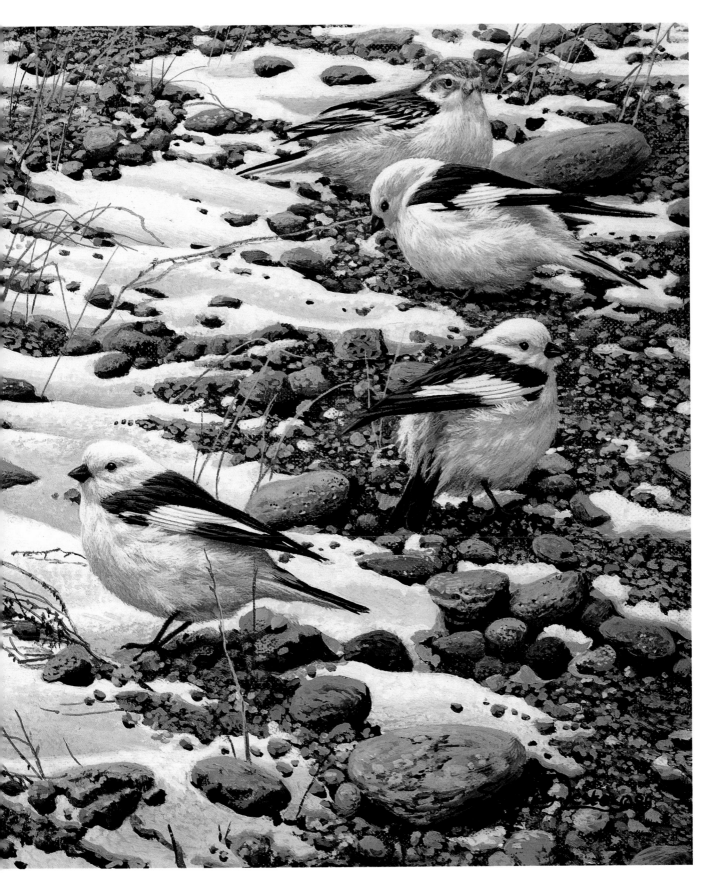

# RENDERING WATER EFFECTS REALISTICALLY
*Daniel Smith*

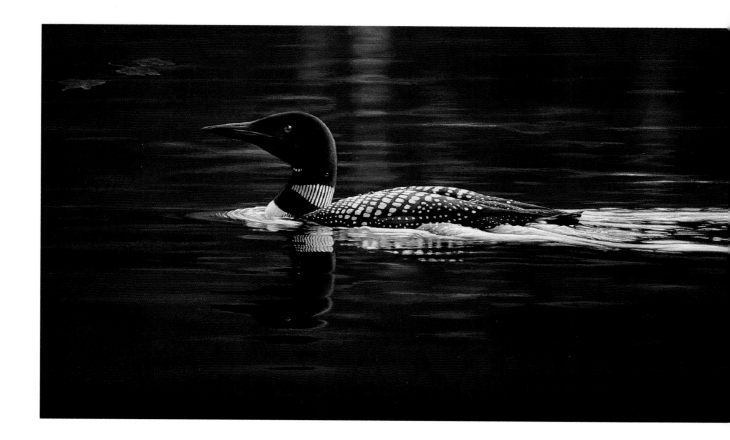

## PARTING REFLECTIONS

*1994, acrylic, 10" × 36" (25.4 × 91.4 cm).*

A loon trailing a long, flashing wake on a dark pond proved irresistible to former commercial artist Daniel Smith, who chose an extreme horizontal format to showcase the graphic potential. "I didn't want to do anything vertical to it, there was so much fluid negative space," he explains.

He painted his entire board dark green, consisting of a syrupy mix of Payne's gray, ultramarine blue, and Hooker's green, to indicate the water. Although there is no horizon, he creates the illusion of depth by making the water lighter at the top of the painting and darker at the base. "I try always to give the corners of a painting extra weight to lock the eye within a piece," he says.

The loon's body consists of the same dark mix. Its "necklace" is made up of feathers that actually stand out from the neck like strips of short fur. Smith emphasized their three-dimensional quality with shadows. He used a Heinz-Scharff 3000 series No. 3 sable watercolor brush for such detail; he finds this French brand more durable than others, and "it holds more paint."

The loon's reflection is in deep water and so is painted darker than the bird itself. If it had been closer to shore where the water is more translucent, the reflection would have been lighter than the loon. Reflections are often warmer in color than the subject itself. Here, soft pink passages in the neck and body reflections warm the tones. Smith was careful to reflect the blue of the sky in the long wake. Surface shimmers were created with an airbrush.

The water bubbles were painted as transparent domes: "They're tricky," says Smith. "They seem like water droplets, but they're not as solid—merely a thin film of water—and they don't refract light the way droplets do. They've got to have structure although you can see through them. And they're *on* the water so they have to reflect into the water."

The orange leaves were added last. To understand better how they reflected, the artist collected maple and elm leaves and placed them on a mirror to simulate the water's surface. Positioning the loon and its wake in the center of the painting evokes the peace and quiet of the habitat in which it lives.

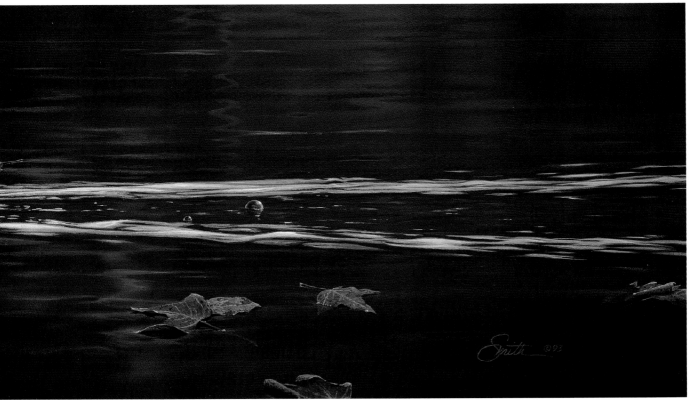

*In creating the water droplet on the loon's neck, Smith made the end closest to the light source dark, and the opposite end light, as his preliminary sketch shows. After the paint had dried, he put a cast shadow under the light end and a small highlight in the dark end. Droplets are always the same color as the surface they are on.*

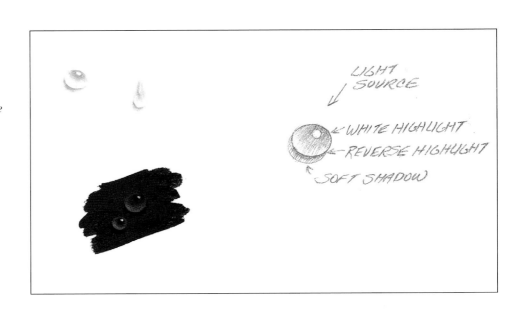

LIGHT
SOURCE

← WHITE HIGHLIGHT
← REVERSE HIGHLIGHT
← SOFT SHADOW

# PREDATORS ON THE MOVE

*Lee Kromschroeder*

*Dino Paravano*

*John Seerey-Lester*

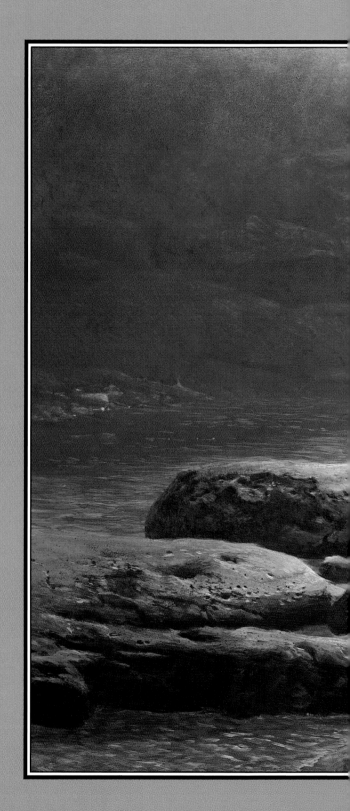

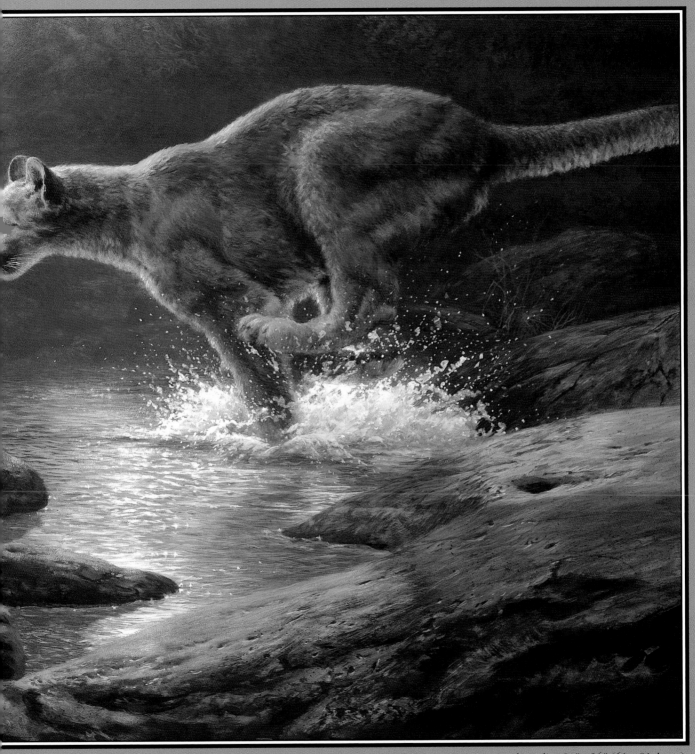

John Seerey-Lester, *Moonlight Chase—Cougar*, mixed media, 24" × 36" (61 × 91.4 cm).

# CONSULTING EXPERTS FOR AN ACCURATE DEPICTION
*Lee Kromschroeder*

## PURSUIT ON THE DECK

*1991, acrylic, 16" × 36" (40.6 × 91.4 cm).*

Like a fighter plane flying low—"pursuit on deck"—a peregrine falcon streaks after a bufflehead duck just above a lake at dawn. Peregrines are among the fastest birds in the world; radar has clocked them at 210 miles per hour. Ducks are fast too, but their 30 to 35 miles per hour is no match for the falcon. Or is it? From the falconers he consulted, artist Lee Kromschroeder learned that peregrines are speedy when they tuck their wings against their bodies and drop like a rock from great heights. But once it is flying level, a peregrine can't keep up with a duck hurrying to get away.

To emphasize the speed of the birds, the artist wanted the contrasting Zen-like calm of dawn in the setting. He began by painting the whole surface bright cadmium orange, in keeping with the colors of sunrise. Then he overpainted it with a mix of Payne's gray and violet. As he moved from bottom to top, he layered it thick to thin so that more and more of the orange came through. Kromschroeder also chose a horizontal format, which gives his subjects more of that early morning calm to be moving through. He blurred the tips of both birds' wings, and touching one of the peregrine falcon's wings to the

water surface helped to establish their position in space. The ripples above and below the pair, along with the placement of the reeds, visually narrow the escape route.

Peregrines do not have a duck's maneuverability, and this is reflected in the birds' poses. The peregrine's tail feathers are spread to turn to the left, while the bufflehead is already rolling to the right. Should the falcon catch up with the bufflehead, its feet will swing forward to knock it down. But peregrines don't like to get wet, and a duck will somersault into the brink to escape.

"People figure the duck's a gonner, but it's not an open-and-shut case," the artist says.

After the peregrine passed muster with the falcon experts, Kromschroeder took the painting to a show — only to have a waterfowl expert criticize the duck. "Make the bufflehead's body fatter," he urged the artist, who has painted hundreds of ducks in his career. As he started to tamper further with it, adding more reeds, it took another friend to tell him, "Lee, peregrine falcon . . . bufflehead . . . end of story," before he finally quit.

# LAYERING COLOR AND GESSO FOR ATMOSPHERIC EFFECT
*John Seerey-Lester*

## RANTHAMBHORE RUSH

*1992, acrylic, 24" × 30" (61 × 76.2 cm).*

The soft yellow atmosphere that suffuses *Ranthambhore Rush* is typical of the light in India—"unlike anything else in the world," says John-Seerey Lester." Suddenly into the peaceful scene bounds a tiger, chasing some sambhar deer grazing at the shore of a lake. Each encounter with tigers has been a heart-stopping experience for Seerey-Lester. "The sudden speed of a tiger's rush into the water is both amazing and unnerving," the artist recalls.

Seerey-Lester handles acrylics like watercolor, and this includes his use of gesso. To paint this scene, the artist first primed a Masonite panel with a gesso mixed with burnt umber, Payne's gray, and French ultramarine in equal parts—a middle-value gray. He then built the painting up with transparent washes "as though it's coming out of the fog." He painted the tiger and the grass first, then washed the whole board with yellow ochre and thinned-down gesso, putting more at the top to give the feeling of light coming in through the haze. The lower half of the panel received additional glazes of yellow ochre and raw sienna, then a thin, atmospheric layer of gesso again.

Painting the tiger, which he kept small to emphasize the height of the elephant grass, the artist used yellow ochre, burnt sienna, and ultramarine blue. The grass was painted with a 1¼" flat brush in strokes from the water's edge upward. "I make sure the brush is really flat, and then I drag the paint," the artist explains. "I keep my wrist very stiff. If there is any wrist action, the grass will get thick and thin in places where I don't want it to. I basically paint from the shoulder." Behind the grass, the base color is allowed to show through.

The painting gradually darkens. When he feels he has put in enough detail, he reverses course with the thin layer of gesso and color that represents the atmospheric haze. Final details are brought forward from that, and pushed back into paleness again with a final wash. For example, the splashes, painted with gesso combined with Naples yellow, were painted as little shapes built of droplets—each droplet is individually put on—then glazed over several times. "I'll put a wash on it, and then I'll bring it out again. Put another wash on, then bring it out again. Each time I emphasize it, it has more depth," the artist explains. He rubbed his finger along a toothbrush for the finest spray.

As a final step, Seerey-Lester put in the bright highlights he wanted to gleam through the haze.

By not including the sambhar deer, Seerey-Lester takes the viewer's eye through the painting. "People ask me what made the splashes, but it doesn't really matter," he explains.

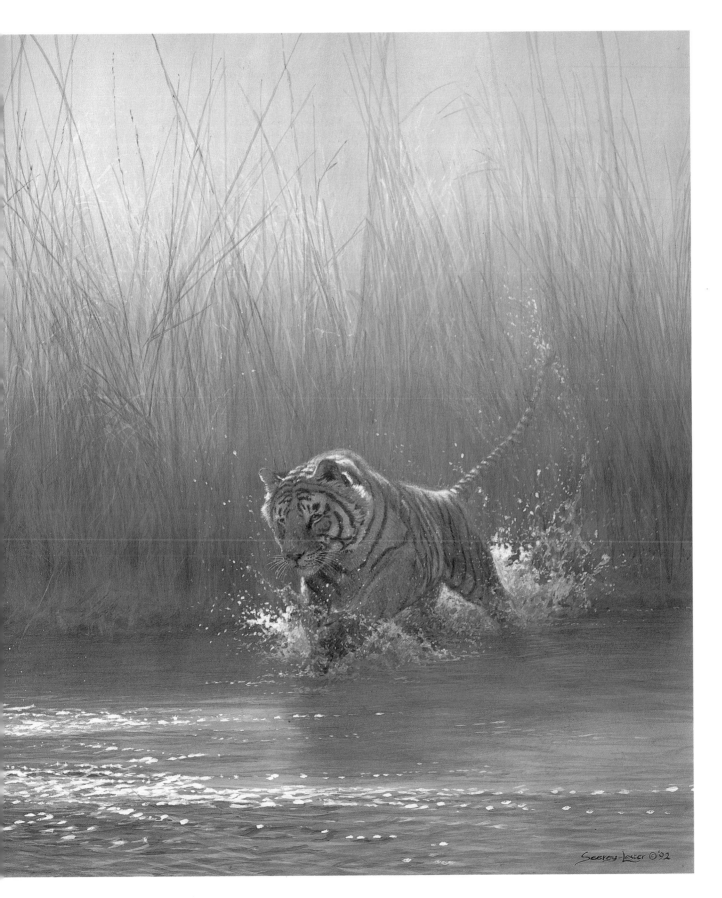

Seerey-Lester ©'92

# CREATING MISTY NOCTURNES IN OILS
*John Seerey-Lester*

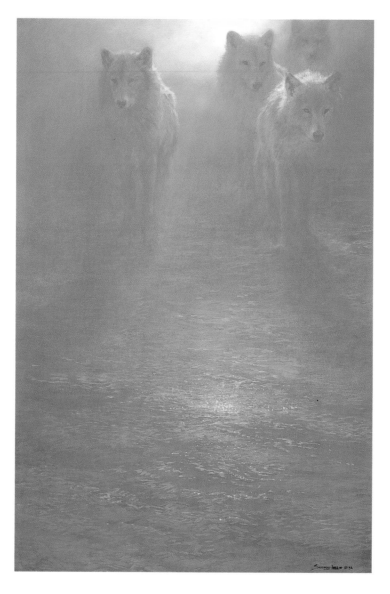

## FROZEN MOONLIGHT

*1993, oil, 36" × 24" (91.4 × 61 cm).*

As moonlight filters through an arctic mist, a wolf pack emerges from the darkness looking for prey. To artist John Seerey-Lester, they formed interesting positive and negative shapes. "I wanted the wolves to appear as ghostly mirages, and to blend with the frozen tundra," he says. He placed them high in the painting, partially silhouetted in the moonlight, and left the remainder of the painting an atmospheric void. "My intention," he explains, "was to have a very soft feeling to the painting, and for the viewer's eye to be drawn to the light at the top."

He painted the scene in acrylic at first, but the medium wasn't subtle enough, and the wolves were too obvious. Using oil paint, he laid a veil of blue-green over the acrylic wolves, but this color—a mix of ultramarine blue, Payne's gray, and yellow ochre—was too vivid. Then a

happy accident occurred. "I started wiping off the oil with turpentine and suddenly there was the effect I wanted," the artist says. Moving carefully, he lifted off small amounts of the wiped paint here and there, re-exposing the lightest parts of the wolves as he had formerly painted them. When the oil dried, he put in delicate touches of titanium white and Naples yellow for the highlights.

Seerey-Lester then drybrushed the effect of softly filtered light and the highlights on the foreground ice. To get the sparkles, the artist made little stars of Naples yellow and titanium white, adding a point of paint in the center of each after the paint dried. Final touches of flesh tint on the wolves and in the snow warmed the scene and kept it from being too greenish.

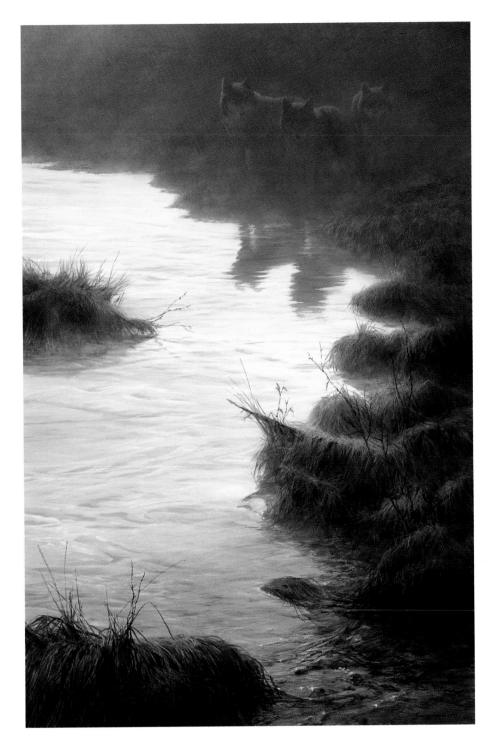

## Phantoms of the Tundra

*1992, oil, 36" × 24" (91.4 × 61 cm).*

Huddled in a camper on a wolf watch in Alaska, John Seerey-Lester looked out across a pond at dusk. Only the light reflecting faintly on the pond was visible. As he did a field sketch in acrylic on paper, a moose walked across the scene, so he quickly painted it in. When he got back to the studio, he thought the painting would be more interesting with wolves.

*Phantoms of the Tundra,* like *Frozen Moonlight,* was originally painted in acrylic and reworked in oil. The image was suffused with thin layerings of burnt sienna, raw sienna, and Payne's gray. The artist used the foreground to draw the eye away from the wolves—intending the viewer to notice first the reflections, then what is making them. The wolves were drybrushed into the background for a misty look.

Highlights in the water, and then the ripples, were put in, and these were blended with the edge of a flat brush. Final touches include Naples yellow along the edge of the pond and drybrushed Payne's gray, burnt sienna, and titanium white for the wolves' breath.

# USING AN UNUSUAL ANGLE FOR IMPACT
*John Seerey-Lester*

## THE CHASE—SNOW LEOPARD

*1992, oil, 36" × 48" (76.2 × 122 cm).*

One way to maximize the impact of a predator on the attack is to make the viewer the prey. Here, a snow leopard in face-forward motion is seen from an unusual angle, from slightly above as it is running downhill.

John Seerey-Lester painted this big cat's head in sharper detail than the body, further conveying the sense of its forward rush and creating pictorial depth. Bright sprays of snow at its feet indicate speed. Tracks converging on and then suddenly veering from the predator's path give evidence of its prey. The artist made the leopard's cast shadow and the curve of the snow bank at the top of the painting integral to the design.

The snow leopard's impassive yet riveting eyes are the focal point. "I like to have animals gazing beyond the viewer, which gives the painting another dimension," Seerey-Lester explains. Its eyes are yellow ochre, with Payne's gray added at the top and white added at the bottom; a touch of yellow ochre indicates reflected light along the bottom rim.

Seerey-Lester preferred oil as the medium to capture the softness of the leopard's fur. He handled the spots with paint texture rather than trying to put in each hair. "Snow leopards have a complex coat," he notes. "Their markings are not as noticeable as other big cats' because of their long, thick fur."

In the snow, brights were put in first, followed by the shadows, which give form. Seerey-Lester explains: "As a general rule, when painting wet-on-wet in oil, you can always darken a light area, but you can't easily lighten a dark one." If you put in dark or middle values and then try to lighten them while they are wet, the color won't be clear, he continues, because oils blend a lot more readily than quick-drying acrylics. Here, the whitest whites are titanium white, with a touch of Naples yellow. "Never use pure white, it's much too cold," Seery-Lester advises.

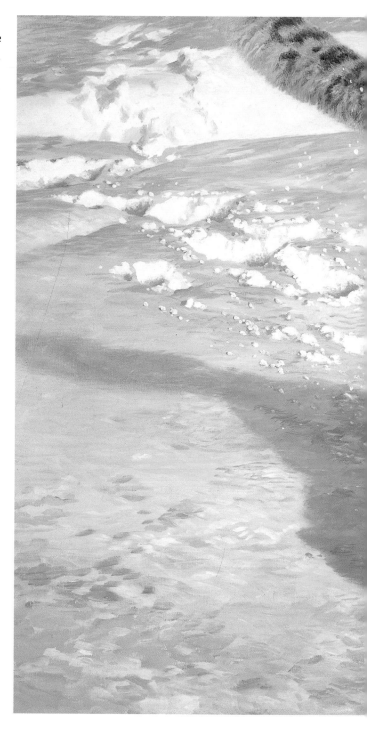

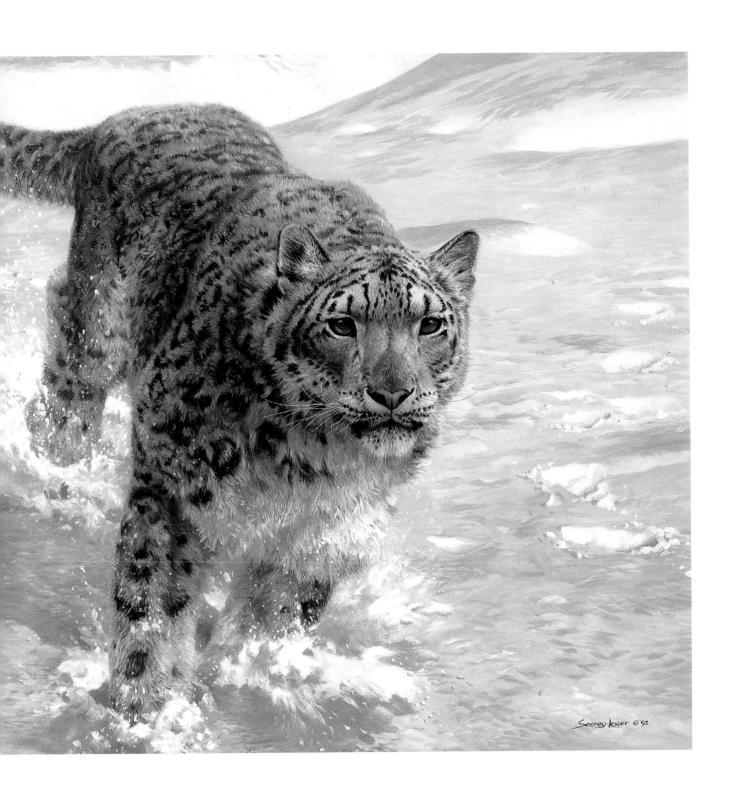

Seerey-lester ©'92

# Layering Colors in Pastel
*Dino Paravano*

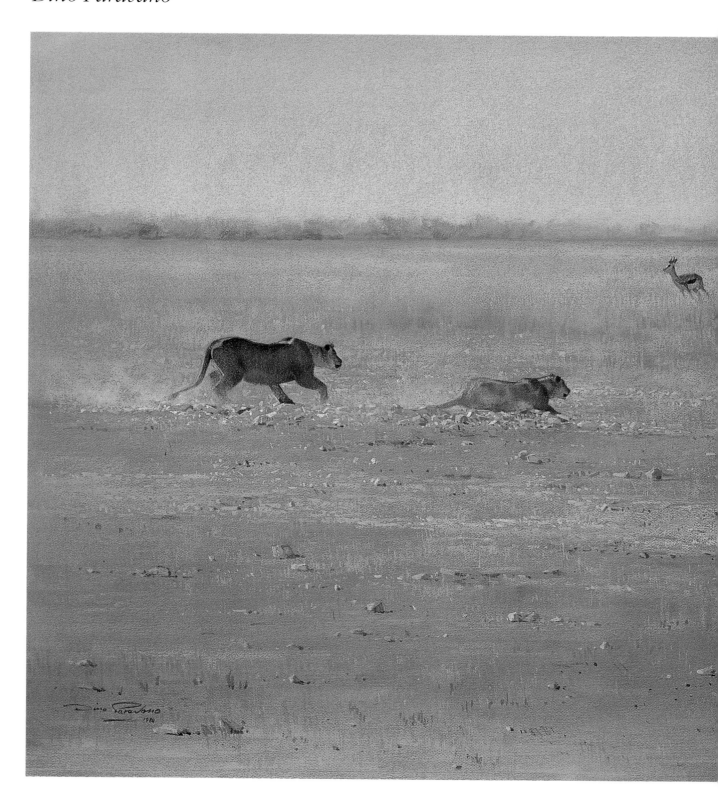

# THE CHASE

*1988, pastel, 28" x 42" (71 x 106.7 cm).*

Reversing the approach of John Seerey-Lester's *The Chase — Snow Leopard*, Dino Paravano's *The Chase* depicts its subject from a distance, conveying setting and atmosphere. "If I had painted this close up, I would have lost the feeling of space," says pastelist Paravano. "I like the panoramic view. I would have liked even more space."

Two lionesses begin a slow-motion stalk of springbok on the African plain, flattening themselves and then creeping forward, gradually building up speed. The sense of movement was achieved by raising dust clouds behind the lions and by blurring the antelopes' feet. Trees in the background were merely suggested. "Forget what you see. Paint what you want to see," the artist advises. "Concentrate on the foreground and subject, and use less detail in the background, where it's not as important." The background was completed before the animals were finished, to avoid smudging them.

Paravano's pastel method resembles that of watercolor painting, as he works the whole picture in thin layers of color first. He started with the sky, using semihard NuPastel blue-gray, and then drew in the darkest darks and lightest lights to establish his range of values. To convey the heat of the African plain, the artist chose a pinkish Canson pastel paper, which he allowed to show through everywhere, warming and tying together the colors. "It acts like a glaze," Paravano says. "I let the paper work for me."

Because every stroke is permanent, each is carefully planned and then spontaneously applied. The artist uses tortillons and the heel of his hand to blend. He brushes or blows off excess powder, lifting any that remains with a kneaded eraser, if necessary, to avoid damaging the paper. Paravano uses a fixative only where he signs his name, otherwise avoiding the spray, which darkens colors considerably and destroys the colors' luminosity. Pastels are pretty tough, he has found, and can take handling as long as they are not smudged from side to side. The artist transports his pictures rolled up, a sheet of acetate taped to one edge only, to encourage careful viewing.

# COMPOSING THE PICTURE TO TELL A STORY
*Lee Kromschroeder*

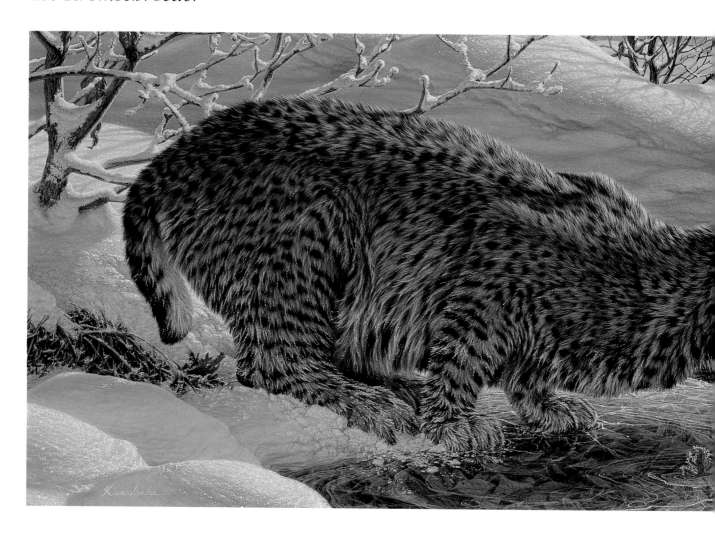

## SKATIN' ON THIN ICE

*1989, acrylic, 12" × 36" (30.4 × 91.4 cm).*

In the age-old game of cat and mouse, the rules—and usually the outcome—don't change. Here, Lee Kromschroeder's idea for a contest between a bobcat and a deer mouse came from a set of photographs he had taken of a recuperating bobcat, which was chasing a stuffed dinosaur on a fishing pole. One image showed the bobcat tilted as far forward as it could go without falling over. "It looks like it doesn't want to take another step," thought the artist. "A step out onto something . . . thin ice!" He decided a picture based on the photos should tell a story.

The artist put kicked-up snow beneath the cat's feet to indicate a pounce; perhaps it even knocked its prey onto the ice. The terrified mouse, skittering away on tiny feet, tugs at the viewer's heart. "So many people say to me: 'Please tell me the mouse got away,'" the artist relates. "Maybe, but those cats fish for trout. The truth is, in the next second there is going to be a bunch of smashed ice and a wet bobcat scarfing down a meal."

Kromschroeder built the painting around the bobcat's intense stare, choosing a narrow format to further squeeze the horizontal scene. He focuses on the cat's face by lighting it against dark water. Its dark body, on the other hand, is silhouetted against bright snow.

For the story to be clearly told, the mouse had to gain the viewer's equal attention. Originally, the artist planned to have clear ice beneath its feet, with stones and dead leaves showing through. But such objects are mouse-sized and mouse-colored and nearly hid the mouse instead. So the artist frosted that section and moved the see-through area to the feet of the cat, where it wouldn't compete. The artist used an airbrush to keep the underwater shapes blurred and distorted, then came back with a brush for detail. The snow was handled in a similar manner, with soft lavender-gray shadows.

Kromschroeder painted each aspect of the picture with the same intense focus. "When I am painting snow, I'm Mr. Snow Guy," he says. "When I'm painting the animals, I am Mr. Bobcat, and then Mr. Mouse."

# IN FOREST HAUNTS

*Alan M. Hunt*

*John Seerey-Lester*

*Richard Sloan*

*Daniel Smith*

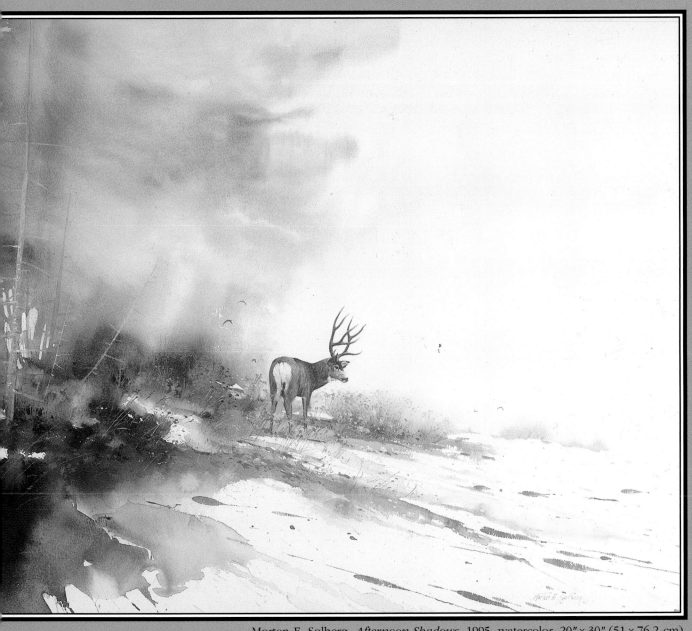

Morten E. Solberg, *Afternoon Shadows,* 1995, watercolor, 20″ × 30″ (51 × 76.2 cm).

# USING THE LIGHT SOURCE TO GOOD EFFECT
*John Seerey-Lester*

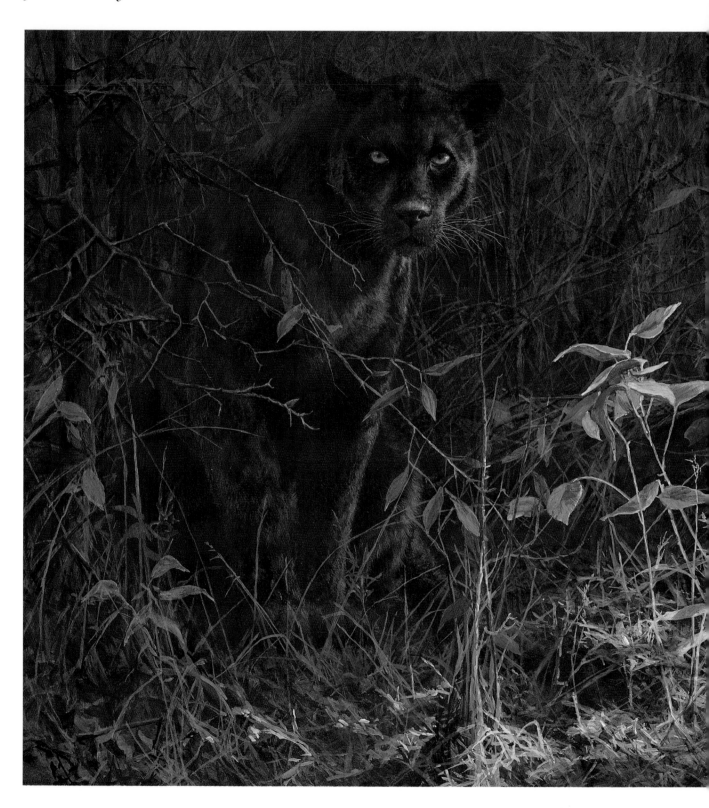

# BLACK MAGIC

*1992, acrylic, 24" x 36" (61 x 91.4 cm).*

The light source can make or break a painting. Here, artist John Seerey-Lester lets the light sparsely penetrating a thicket work for him. In *Black Magic,* he uses sunlight patches to distract the viewer from the subject, a black leopard, only to have the animal's baleful eyes draw the attention back again. "To me, the black panther is one of the most magnificent of the big cats and, as an incurable romantic, I prefer to think of this creature as a solitary animal of mystery," the artist says. To enhance its mysterious nature, he kept the range of values narrow and dark. Thus the big cat almost disappears into its shadowy surroundings.

Seerey-Lester started with the panther. Working on a gray panel with a mixture of burnt umber, ultramarine blue, and Payne's gray, he kept his acrylic paints transparent and maintained much lighter values than the finished piece would have. The thicket was then laid in with the same dark mix.

Before the paint dried, the artist lifted random highlights to create impressions of branches and leaves, and then he darkened the thicket areas again with a wash. Next, a raw sienna wash, for warmth, covered both cat and setting. Detail work on the cat was followed by two more dark washes, until cat and setting were almost the same dark value.

Final details were laid in with more opaque paint. Seerey-Lester reemphasized the highlights using a mixture of gesso with his colors. Then he laid in a series of alternating washes consisting of a dark mix of ultramarine blue and burnt umber with raw sienna and yellow ochre. The use of yellow ochre, which is the most opaque of the washes, brought all the values closer together.

The foreground grass consists of gesso mixed with Payne's gray and some burnt umber. The green leaves are a combination of yellow ochre and ultramarine blue. Working around the leaves, Seerey-Lester applied four or five washes of Payne's gray on every area except the highlighted areas of the foreground at bottom right, using a hairdryer to speed the drying process. "I've put in as many as 200 washes on some paintings," he says. "It's important to apply them slowly and gently. If you go too fast, you will get hard edges and you'll never be able to get rid of them." His finishing touches were the strategic highlights on the more brightly lighted foliage.

# MASKING AND AIRBRUSHING IN WATERCOLOR
## Carl Brenders

## PATHFINDER — RED FOX

*1991, mixed media, 25½" × 38" (64.5 × 96.5 cm).*

Much of Carl Brenders' technique has evolved from his years as a commercial artist. "I found by doing illustrations for children's books that airbrushing is a good way to gain time," he says."You could reach the same result without an airbrush, but it takes a lot more work and time." With his passion for capturing every nuance of feather, fur, and foliage, Carl Brenders comes as close to replicating nature as any wildlife artist painting today. For *Pathfinder—Red Fox,* his complex and original technique included airbrushing, masking, watercolor, and gouache.

First, Brenders did a detailed pencil composition about the size of a postcard, in which he established the form and light-and-dark values of the animal in its forest setting. The drawing was resized in an enlarger and transferred to illustration board. Brenders strengthened the drawing with sepia watercolor. At that stage, it looked like a dark brown pen drawing.

Next, he took an acetate sheet and cut out a silhouette of the subject and whatever else he wanted to mask—in this case, the foreground and the tree. "I want to save the whites for my animals because my watercolor technique

only works well on a white paper," Brenders explains.

Holding the acetate in place with small lead weights, the artist airbrushed the background with transparent watercolor layers, following the values indicated in the drawing. The color was about 20 percent too dark on purpose, so that he could work on it from dark to light with gouache. "You have to know how much to make it too dark," Brenders says. "That's very important. If it's too dark, it's hard to undo."

He worked on the background to completion, painting the details in gouache. "I want to be sure that the background is okay and that I will not spoil it," the artist comments. "The animals are never a problem, but the background sometimes is. I measure the values and colors of the animals against the colors of the background that I have already done." Often he adds more details in watercolor on top of the gouache, working with very little water and using a hair dryer to fix effects when he has exactly what he wants.

Next, Brenders covered the background, took the acetate off his subject, and proceeded in the same manner, from sepia drawing to airbrush layers to final details.

*Brenders placed acetate masking over the areas to be protected. Here he has masked the fox and painted the background.*

*Brenders built up his leaf and log details in gouache, over the sepia watercolor base.*

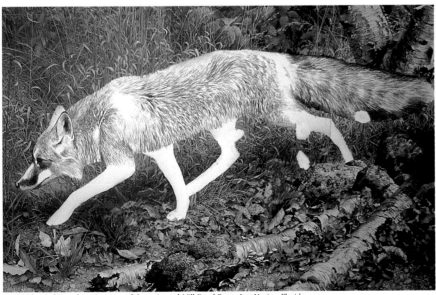

*The artist most enjoys putting in the fur with gouache. "That's the best part of the painting. You see it coming alive," he says.*

# USING ACRYLICS IN AN OPAQUE STYLE
## Richard Sloan

## JUNGLE MORNING

*1989, acrylic, 16" × 20" (40.6 × 50.8 cm).*

In a misty jungle in northern Peru, the morning sun briefly illuminates a rare sight—a crested quetzal perched quietly on a liana. Few people ever get a glimpse of these crow-sized birds, which live high in the canopy, 100 feet or more above the ground. "I wanted to create a sense of presence, to take the viewer to this place to see a secret of the jungle you would never ordinarily see," comments Richard Sloan.

The brightly colored bird, a male, is seen in the indirect light that is typical of rain forest settings, and Sloan has considerably toned down its vivid hues except for the small sun-struck spot where breast and neck meet. "The primary element that triggers my painting is light," remarks Sloan, "light on the foliage, light filtering through the jungle growth, and light shining through the translucent leaves. Multiply that effect by the endless variety of twisting lianas and lofty trees, and you can better understand the hypnotic hold that the jungle has on me."

Sloan has been specializing in rain forest depictions for years. He feels comfortable in the nurturing environment of the jungle, where life seems to spring forth everywhere. "There are no vacuums, no empty spaces. Every nook and cranny is occupied by some form of life. And everything is interdependent on everything else. It's the perfect ecosystem—the perfect system for life."

The jungle's daily temperature is about 85 degrees, and humidity approaches 100 percent, so Sloan doesn't work on location, because the paint would never dry. "You have to get into the mindset that you're going to be soaking wet from the time you get off the plane until you leave," he notes. He takes photographs instead, using a Nikon 35mm camera with 28/85mm and 75/300mm zoom lenses, plus a 600mm mirror lens.

The artist works on untempered Masonite, which he primes with acrylic gesso, five coats on the front and two on the back to seal the surface. For *Jungle Morning,* the final two front layers were toned gray-green.

Sloan decides on a subject and then builds the rest of the painting around it, working from the center outward. He mainly works in a very opaque style, applying paint with a creamy consistency. When he wants to punch up the warmth, he mixes up a glaze, using acrylics like watercolor, and applies them in thin transparent washes. Acrylics lose their binder when diluted with a lot of water, so Sloan adds a matte medium to seal the color. "Medium replaces the binder and stabilizes the pigment," he explains.

Here, he has used the ropelike lianas and the airplants, called bromeliads, like stage props. "The nice thing about jungle growth is there's this riot of greenery," says Sloan, "There are no rules."

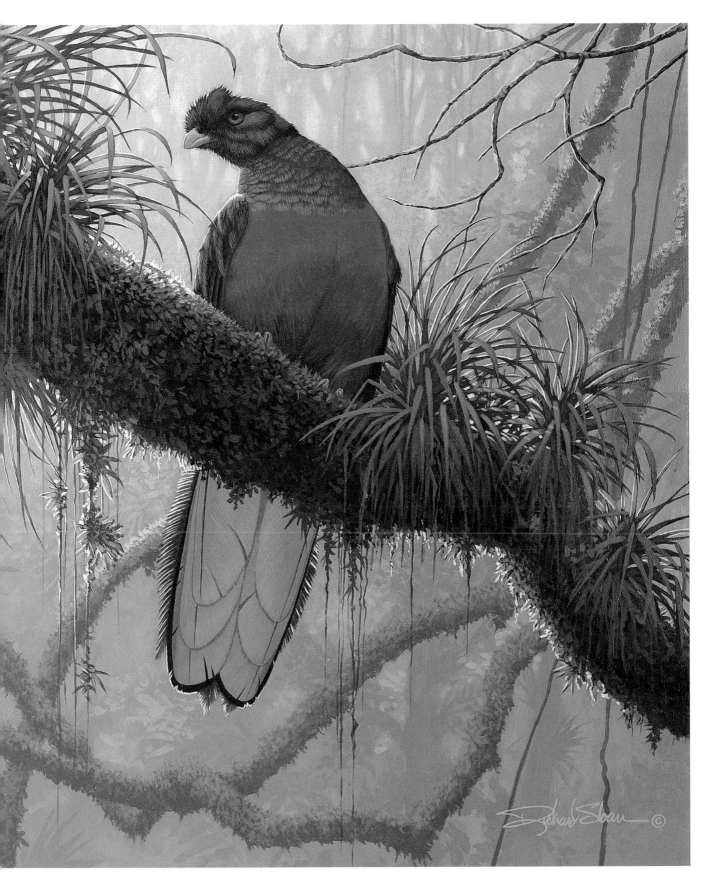

# LEADING THE EYE WITH LIGHT
*Richard Sloan*

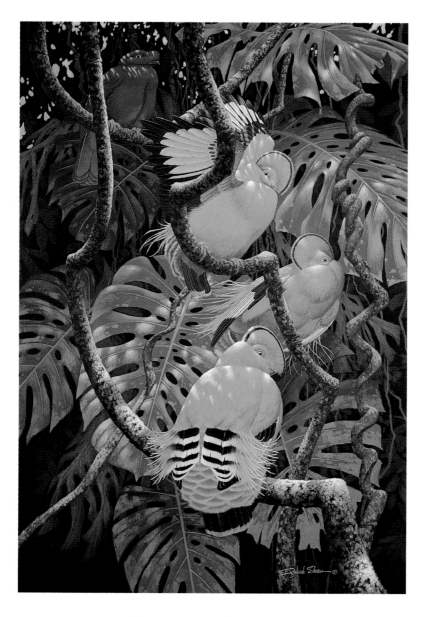

## TANGERINE DANCERS

*1994, acrylic, 28" × 20" (71.1 × 50.8 cm).*

Richard Sloan began to focus on the rain forest in his art around 1980, when he painted a seven-inch-high portrait of the Guianan cock-of-the-rock for a minatures art show. It was the first time he had attempted a jungle scene with dappled light. It was also the first painting in the show that sold. "I thought, 'Hey, maybe I've hit on something here,'" the artist recalls.

This painting, *Tangerine Dancers,* features a group of Guianan cock-of-the-rock males displaying on their courtship grounds, where they jump from branch to branch, whirl around, and "hop and holler" to get the attention of the brown female nearby.

The showy orange birds are eye-catching against a background painted with Hooker's green deep. "I call myself a basement painter," Sloan says. "I keep it as dark as I can to make the lights pop out."

The philodendron leaves are emerald green, with permanent green for highlights. Dried leaves in the shadow are raw sienna blended with some green. The corkscrew branch has a lot of cerulean blue. All have been grayed down.

Throughout the painting, Sloan uses the dappled light as a trail for the eye to follow. Light draws the eye to the drab female, otherwise inconspicuous at the upper left. "It's a planned, random thing," he says. "I have pre-planned the major areas of light. Then I just get in there and let the rest happen."

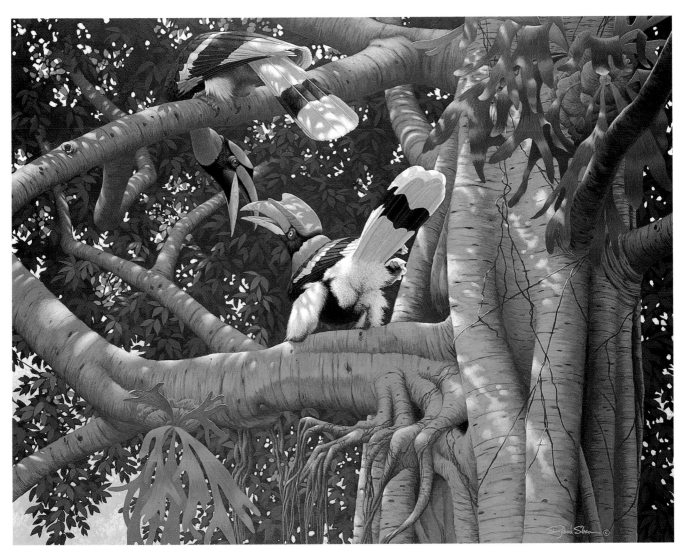

## A LITTLE ROMANCE

*1993, acrylic, 30" × 38" (76.2 × 96.5 cm).*

Light patterns are equally important in *A Little Romance,* portraying the courtship of two great Indian hornbills. Dappled light helps place the birds in space, while the background screen of light and leaves give the piece a dancing feeling. Staghorn ferns add a decorative touch.

"I design with light," says Sloan. "I will paint a deep jungle scene in almost local color, as though it were in shadow. Then I'll create a pattern of sunlight playing on the leaves, birds, branches—very selectively design the light coming through the upper story to flow through the painting as a pattern against the medium and dark tones."

The lightest spot in a highlight may be the highest in value, but it's not the most brilliant," Sloan advises. "The area of greatest color intensity will always be just where light meets dark."

Here and there, edges of the hornbills' bodies are lost where their black plumage blends with the background, which prevents them from looking cut out and pasted on.

*In his sketch for* A Little Romance, *Sloan built the composition around the banyan tree with its aerial roots; the birds make a circle within a larger circle of branches.*

# Using Atmospheric Perspective
*Richard Sloan*

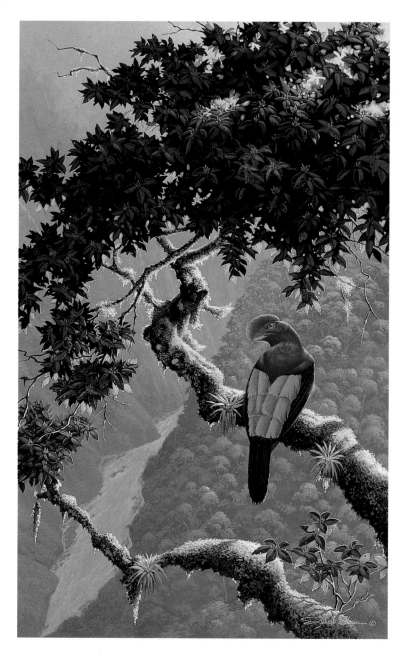

## Above the Urubamba

*1988, acrylic, 29" × 18" (73.6 × 45.7 cm).*

Climbing a steep, ancient trail to the lost Inca city of Macchu Picchu in the Andes, Richard Sloan was stopped by the beauty of early morning light behind an old tree covered with plant growth. "The light on that tree was fantastic," he says, "like a little fairyland." He placed an Andean cock-of-the-rock on a branch, its cadmium red crest backlit by the sun.

The view pitches a dizzying 1,000 feet to the Urubamba River, which feeds into the upper Amazon. Sloan created the illusion of height and space by employing a principle of color called *aerial perspective*—using color that is cooler, lower in intensity, and lighter in value

to convey distance. Seen through the atmosphere, objects become cooler, more muted, and paler the more distant they are. (Generally, they appear warmer and their colors have more brightness as they come closer.) The artist doesn't need to use this color alteration in a dramatic way; the change can be slight. Here, the forest greens become just a little duller as they recede from the viewer. The angle of view also contributes to a sense of depth. With no sky visible in the design, there is nowhere to look but down.

Irregularity is a principle of good composition, and here Sloan has unevenly distributed the space between

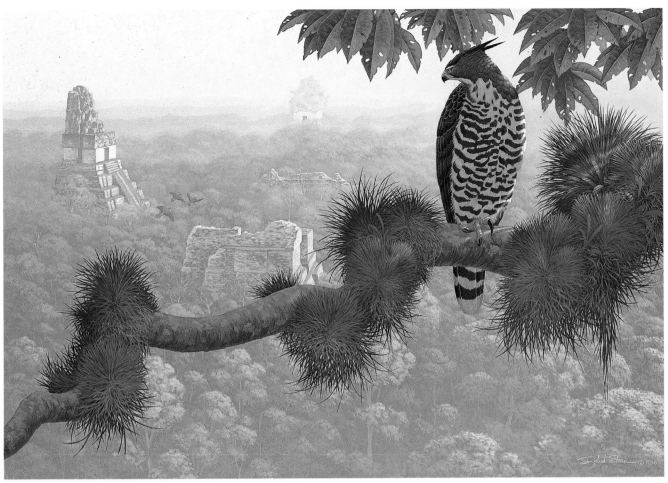

Richard Sloan, *The City at Sunrise,* 1986, acrylic, 20″ × 30″ (50.8 × 76.2 cm).

*An ornate hawk eagle on its perch overlooks the Mayan ruins at Tikal, Guatemala. A mixture of warm rich reds dominates the foreground, while the distance is represented by cooler, less intense, and paler colors.*

*Sloan sketched this denizen of the rain forest, the ornate hawk eagle, for* The City at Sunrise.

his focal point (the bird) and the borders of the painting. "You have to consider the edges of the picture space," Sloan says. "These are things people tend to forget about. They end up with the main shapes exactly the same distance from each other, or exactly the same distance from the painting borders. Irregularity is the key."

When *Above the Urubamba* was first exhibited, a young woman looked at it for a long time and then came over to Sloan and said, "The feeling of space and height in that painting makes me want to throw up." Sloan took it as a compliment. "It was the nicest thing anybody said to me that morning," he recalls.

# GLAZING IN ACRYLICS
*John Seerey-Lester*

## FOREST GLOW

*1994, acrylic, 24" x 36" (61 x 91.4 cm).*

The idea for *Forest Glow* came during John Seerey-Lester's visit to the rain forest in Guatemala. "One morning, before daybreak, a coughing snarl was heard less than 30 yards to our right. On our left were some deer. We were between the predator and its prey." The artist hoped to see the jaguar that had snarled, but the light was dim and the vegetation too tangled for a view. So he did the next best thing — created the scene as he imagined it would be.

Using acrylic washes of yellow ochre and burnt sienna, he painted the jaguar first, and in detail. The foliage was also painted in some detail. The cat and the vegetation were continually reworked as the artist glazed on burnt sienna in alternation with a dark mix of ultramarine blue, burnt umber, raw sienna, and yellow ochre. With each wash he would either reassert the highlights or subdue them again with a shadowy veil of color.

The final touches, in pure gesso, were the highlighted areas behind the cat, which then received a light wash of yellow ochre. A final glaze of burnt sienna was laid over the entire painting.

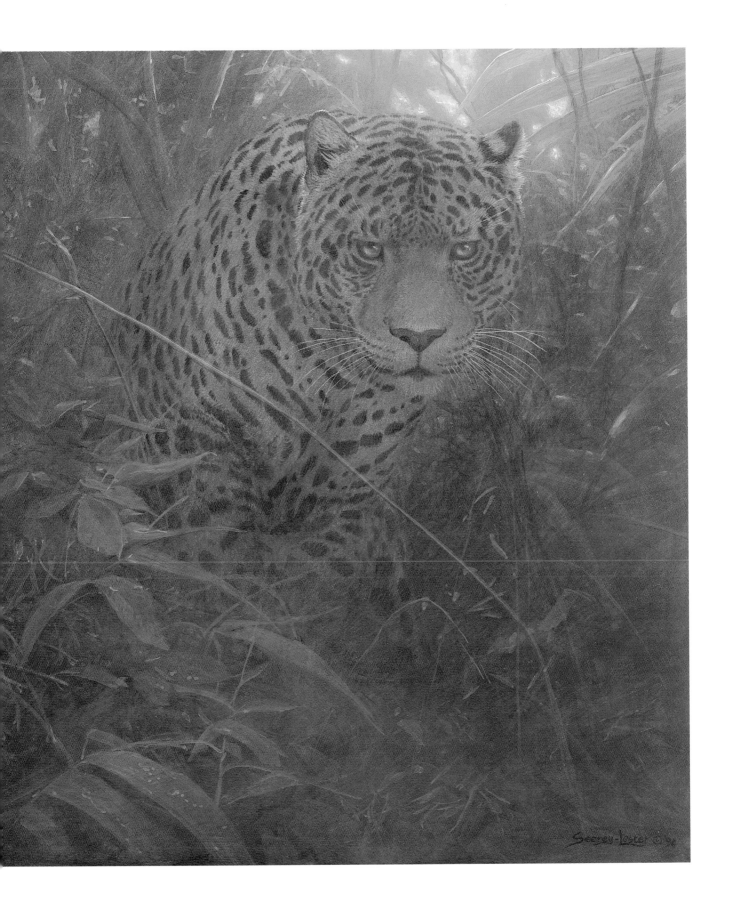

# CAPTURING THE IRIDESCENCE OF FEATHERS
*Alan M. Hunt*

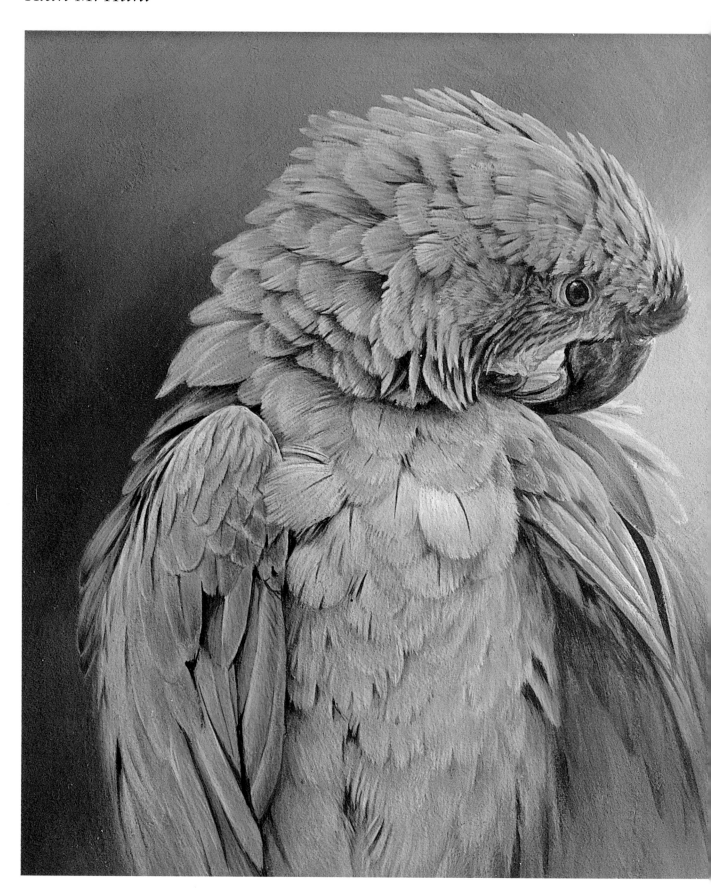

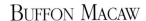

## Buffon Macaw

*1994, acrylic, 8" × 12" (20.3 × 30.5 cm).*

Alan Hunt is fond of the birds of the tropical forest. His disheveled Buffon macaw, depicted in the process of preening, is an iridescent green painstakingly built up with many thin layers of color. "A lot of it is glazing—constantly pushing it back, pulling it forward, again and again, until you get the right mix that suggests you've got a bird with shadows, highlights, and shape," says Hunt. He slowly alters the colors until he's achieved accuracy and then adds reflected light.

Treating the macaw like a ball lit from the front, Hunt first put down a pale yellow wash, then laid in a slightly darker yellow away from its center, gradually darkening and greening toward the wings and head. The original pale yellow became a beautiful highlight glowing through.

To get the basic green, he combined cobalt blue with cadmium yellow, adding viridian on the neck and wings for a richer, cooler green. Yellow ochre, burnt sienna, and cadmium orange were the warmer colors elsewhere. The turquoise wings are a tint of cobalt blue mixed with viridian. The head has a slightly warmer olive color.

Getting the color right is especially important with members of the parrot family, like the macaw. The difference between one green and another can make the difference between one species and another. To capture the brilliant hues, use the paint straight from the tube, Hunt advises. On tropical birds, highlights are not white, but rather the brightest, cleanest version of the local color, and iridescence is achieved by glazing thin colors over white, yellow, or pale orange, then going back with a wet brush and exposing the underlying color again. "Keep it very streaky, so that it looks like the highlights are catching different areas of each feather," the artist advises. This process takes patience. Hunt will glaze as many as thirty times to convey subtle color variations and unusual effects.

© ALAN M. HUNT 94.

# CAPTURING THE IRIDESCENCE OF FEATHERS

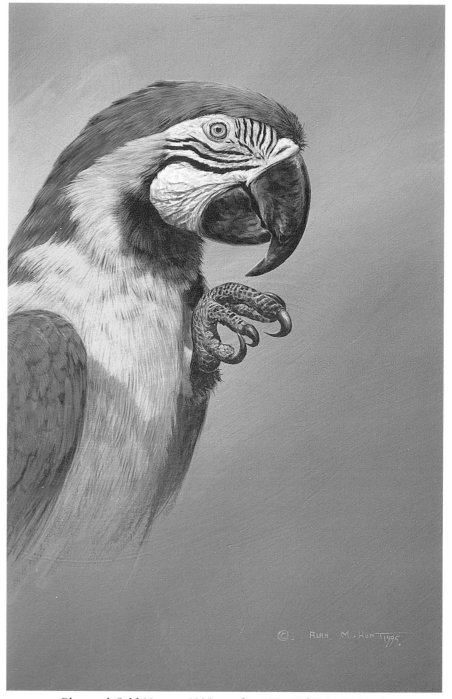

*The turquoise color of the blue and gold macaw was achieved with many acrylic glazes of viridian, ultramarine blue, and cobalt blue, with yellow on top of that. The leading edge of its wing is crimson glazed over ultramarine blue. The top of the macaw's head is turquoise overglazed with olive green. The gold is primarily cadmium yellow.*

*Blue and Gold Macaw,* 1995, acrylic, 12″ × 8″ (30.5 × 20.3 cm).

Alan Hunt used to work with exotic birds at zoos, and he has kept a few as pets. All the large parrots are similar, he says: They come in mostly gaudy colors, can be taught to speak, have huge beaks, and are "real characters" with strutting walks and dances. Some can be intimidating: The large palm cockatoo stamps its feet, makes a loud knocking sound on its branch, and swings forward, crest up, when disturbed, while the hyacinthine macaw, largest of all, can take your finger off with its beak.

*Pair of Scarlet Macaws,* 1994, acrylic, 12″ × 8″ (30.5 × 20.3 cm).

*These macaws began with a scarlet underpainting, then were overglazed withcadmium yellow highlights and ultramarine shadows. Their wings are ultramarine blue and cadmium yellow, and a glaze of white over the blue creates a sheen.*

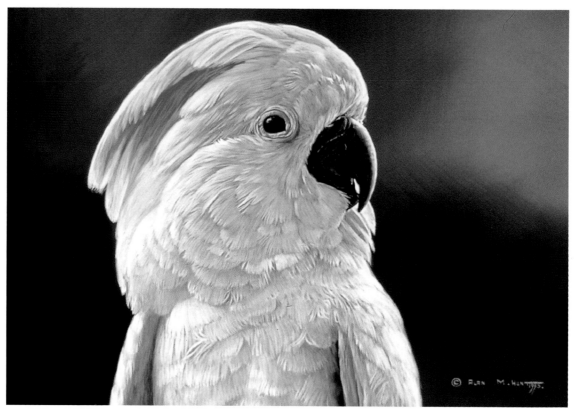

*Moluccan Cockatoo,* 1993, gouache, 10″ x 14″ (25.4 x 35.5 cm).

*Hyacinthine Macaw,* 1994, gouache, 10″ x 14″ (25.4 x 35.5 cm).

The base of every feather on the Moluccan cockatoo (opposite top) has a pink blush to it. When it ruffles its feathers it goes from white to a lovely warm pink. Using gouache, Hunt introduced a blue tint to differentiate the feathers. The crest is cadmium red, with cadmium orange highlights.

*Palm Cockatoo*, 1994, acrylic, 16″ × 12″ (40.6 × 30.5 cm).

The iridescent blue of the hyacinthine macaw (opposite bottom) was hard to capture. Hunt settled on pure cobalt blue thinly glazed over with ultramarine blue and alizarin crimson. He washed over this at the top with white, then overglazed with more cobalt blue. "Gouache was the best medium to use here," he says.

The challenge of painting the palm cockatoo (above) was to keep its color gray, yet lively, and the surface matte, not glossy. The feathers are Payne's gray, with some ultramarine blue added to later glazes. White mixed with the gray gives its foot-long crest a chalky look. Red areas are cadmium red, with cadmium orange for highlights.

# MAINTAINING COLOR WITH NEUTRAL GRAYS
*Richard Sloan*

# THE BEAN TREE

*1995, acrylic, 30" × 24" (76.2 × 61 cm).*

*Painting around the shapes of the birds, branches, and pods, Sloan laid in a background of Hooker's green deep mixed with dark gray. Acacia leaves were indicated in white charcoal pencil. Those at the upper left were done with permanent green deep mixed with No. 3 gray.*

Richard Sloan mixes his colors with grays following a system that allows him to neutralize—that is, to substantially reduce the intensity—of a color while maintaining the identity of the hues. "Most painters don't paint this way. I just picked a system that nobody else uses," he says. "Instead of spending my entire life mixing paint, it lets me concentrate on putting paint on the board."

The traditional way of muting color is to mix it with its complement—the color directly opposite on the color wheel. Green neutralizes red, for example, and yellow grays down violet. But as you add more and more of the complement, the original color loses its identity and eventually turns muddy. The effect of a colorful canvas cannot be achieved. On the other hand, combining red with a gray that consists only of black mixed with white (and thus neutral, with no hint of color) maintains the color as identifiably red all the way down the value scale: "It doesn't become anything but what it is," Sloan asserts.

Liquitex, the first company to manufacture a line of acrylic paints in neutral grays, no longer makes a full range of them, so Sloan mixes Liquitex tube colors, which are labeled by value, with grays made by Golden. Because he paints jungle scenes in which light filters through dense vegetation (such as this picture of military macaws), he uses the system extensively. "Almost every color I use has gray in it," he says. "The use of pure color in my paintings is minimal, and that's what makes them sparkle."

The gray value scale he uses has eight gradations, with No. 8 being lightest and No. 2, which is one notch above black, darkest. Most often, Sloan will mix a value 5 color with a value 5 gray, but not always. "You can work a little darker, or lighter, within a tone, provided that the area remains within the value you have designated," he explains. "Values are everything. If your values are correct, the painting will look all right even if the colors are off."

Working this way saves Sloan time. "I can buy a tube of No. 5 gray and a tube of permanent green light which is already mixed to a No. 5 value, and all I have to do is add that gray to kill the intensity of the green," he says. "I know exactly what I've got, and it didn't take ten minutes to mix it. I get people asking, 'How do you get these tremendous effects?' I answer: "As quickly as I can. I hate mixing paint."

*The leaves finished, he filled in the pods with Liquitex bronze yellow and raw umber neutralized with No. 4 gray. Sloan then began the branch in raw umber and added some sky.*

*The foreground macaw was painted with colors and matching grays in the 3 to 7 value range: cadmium red on the head and tail, bronze yellow with yellow oxide and green on the back, permanent blue light for the upper tail coverts, and cerulean blue for the primaries and parts of the tail. The same colors will be used on the other two birds, only with more gray added to further reduce color intensity and allow them to recede in space.*

# WORKING WITH A LIMITED PALETTE
*Carl Brenders*

# Broken Silence

*1994, mixed media, 21⅛" × 40⅛" (53.8 × 102 cm).*

As with most of Carl Brenders' paintings, *Broken Silence* evolved from a desire to paint a certain landscape: a stream shaded by sycamores—trees that remind him of his youth in Belgium, where they also grow. The setting suited another subject he had been wanting to paint, twin fawns amid the play of light and camouflage patterns.

Brenders has a limited palette in gouache and watercolor. For both, he uses the Dutch brand Talens almost exclusively, more out of long-held habit than anything else. His gouache colors consist of Talens yellow ("a very pure, neutral yellow"), and Winsor & Newton cadmium yellow deep, which is closer to orange and a color he uses in transparent washes for reflections. Next come the earth tones: yellow ochre, natural umber, and light neutral brown. He eschews burnt umber, which is "too burnt, not natural enough" and likely to turn muddy.

His gouache blues consist of blue-green (used a lot for water reflections) and Prussian blue. He doesn't use ultramarine blue in gouache because it leans too much toward purple, whereas Prussian blue leans toward green, "a color seen more in nature." The only tube greens the artist uses are olive, yellow-green, and lemon green; all the others are mixed from yellows and blues. There are no reds on his palette. He keeps a pot of white gouache handy.

Brenders' watercolor selection is similar to his gouache palette. Also mainly Talens products, the paints are cadmium yellow light, cadmium yellow deep, yellow ochre, raw sienna, burnt sienna, Van Dyke brown ("a wonderful, rich dark brown"), sepia ("one of the most important colors on my palette"), vermilion, and carmine, which he mixes with ultramarine blue for the "perfect" purple. His blues include Prussian blue ("the best blue to make greens") and ultramarine blue. He does not like cobalt blue: "It's good for painting people in uniforms, but it's not good to mix for greens," the artist says. Brenders has no tube greens on his watercolor palette, preferring instead to mix raw umber, yellow ochre, even burnt sienna, with Prussian blue.

After the fawns were finished, Brenders felt the left side of the painting needed some action. At first, he put a chipmunk on the log, but it didn't look right. Finally he painted a red squirrel screeching, which suggested the title, *Broken Silence.*

# CREATING AN EERIE MOOD WITH COLOR
*Daniel Smith*

*Smith was able to make many firsthand pencil studies of this black leopard.*

## AFRICAN EBONY

*1993, acrylic, 32" × 24" (81.3 × 61 cm).*

A discolored photocopy of a slide of the upland cloud forest of Tanzania inspired *African Ebony.* "The color went a little haywire; it had a real purplish cast," says Daniel Smith. Instead of rejecting it he decided to use the effect to his advantage, adding dioxazine purple and some lime green to his usually subdued palette. The open, misty scene appealed to Smith. "I loved the shapes of the trees, and the moody, misty veil allowed me to silhouette them and get an incredible depth within a real short range," he says. The result, which he painted with acrylics, has an eerie look.

The black leopard, the same one used in the live-action movie *The Jungle Book,* was one of twelve owned by a California trainer. "They were like house cats," Smith recalls. "We were having dinner and his wife came down the stairs with this black leopard on a chain. The leopards were just kind of hanging around."

For reference, he photographed the animal on an oak log. "I liked the posture, the animation: head turned, mouth open, tail twitching up in anticipation of the next move." He painted the big cat using Payne's gray and dioxazine purple, with raw sienna and burnt sienna highlights.

The painting's underlying background color was a soft wash of dioxazine purple, Hooker's green, and Payne's gray. This color was also used as bounce light. The leaves are predominately Hooker's green; their undersides are a bright lime green airbrushed with purple to mute and warm the green. That's what gives it the eerie cast," the artist explains.

Smith took pains to identify the plants. He liked their shapes, the way the light came through them, "and the way the big leaves at the top mimic the posture of the leopard, turning."

Smith uses an airbrush to push the pictorial planes around. "If I want the background to recede, I paint it a little stronger than I want, then dust it over the top with the airbrush, using the colors beneath it to blend it back into that plane," he says. "There's a lot of handwork in there, too." At the lower left can be seen a tiny tree frog.

# WILDNESS INTO ART: TOOLS AND TECHNIQUES

*Carl Brenders*

*Alan M. Hunt*

*Dino Paravano*

*John Seerey-Lester*

*Morten E. Solberg*

*Leigh Voigt*

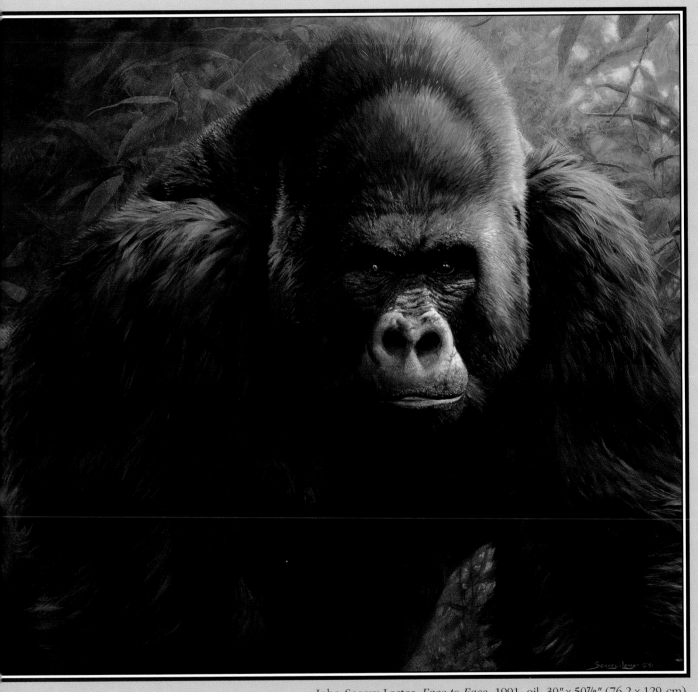

John Seerey-Lester, *Face to Face,* 1991, oil, 30″ × 50⅞″ (76.2 × 129 cm).

# Capturing Cougars Realistically in Pastel
*Dino Paravano*

## Rocky Mountain Cougars

*1991, pastel, 29⅝" × 43⅝" (75 × 111 cm).*

Pastel is a sensuous medium—pure, spontaneous, and direct. To get started, all you need is an array of colors and a sheet clipped to a board. Pastelist Dino Paravano appreciates the range of brilliant hues available, the thousands of tones. "Pastel is a lovely medium," he says. "You don't have to worry about drying time, and I like the soft effects." Here, the artist has utilized the colors and properties of his medium to render big cats with total realism.

Unlike colors in other mediums, pastels can't be altered through mixing to produce more colors; they can only be added one to the other through blending. Consequently, Paravano's palette consists of hundreds of pastel sticks, made by half a dozen manufacturers—from hard pastels made by NuPastel and Conte to softer sticks by Rembrandt and Grumbacher and the very softest made by Rowney, Schminke, and Sennelier. To get those in-between colors he cannot buy, the artist makes his own pastels by mixing dry pigments with a binder, or crushing sticks together in soapy water, shaping the new stick with his fingers, and leaving it at room temperature overnight. "I need the color to be correct. I don't like compromising," he explains.

Paravano starts off using semihard sticks and ends up with thick strokes of very soft ones. "You can work over hard pastels, but soft pastels go on like butter, and you can't work over them," he observes.

The artist chose a dark gray-blue for the background in *Rocky Mountain Cougars*. Using the side of the stick, he made broad strokes, blending them with his hand and a tissue. Next, he laid in the foreground rocks, to establish the middle tones. From there, he worked everywhere at once: trees, sky, leaves, animals, and snow. The cougar's fur was made with sticks sharpened to a chisel point and consists of several shades hatched one over the other—middle, dark, then light. "There's a lot more work in it than you see there," he says.

To keep the rocks looking hard, he maintained sharp edges of light against dark. The snow, by contrast, was applied thickly in soft pastel—white applied over a creamy base and blended.

Paravano prefers the smooth side of Canson pastel paper and, sometimes, sandpaper. He also makes his own gessoed board, adding marble dust for texture. He rarely uses fixative, which takes the glow off pastels.

He found the cougars at a game farm and the setting at Estes National Park in Colorado. "The two cubs good together now, but it was not so easy to fit them into the natural habitat," he recalls. He made many sketches before the captive animals began to look like wild ones. The painting took two weeks to complete.

*Paravano sharpened a brown pastel pencil with sandpaper to do details such as whiskers and the little spots on the cougar's head. The only black in the painting is the circle around the cat's eyes, nose, and jaw, added for emphasis.*

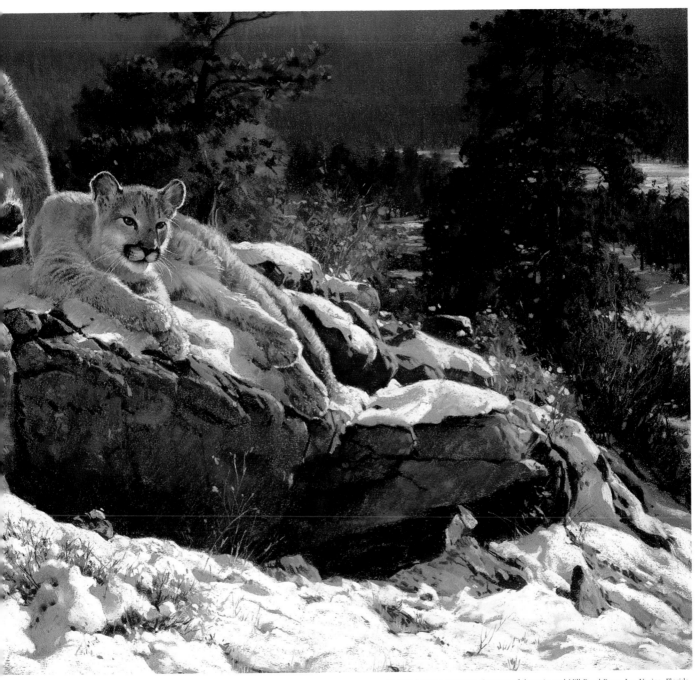

# PAINTING ELEPHANTS IN GOUACHE
*Alan M. Hunt*

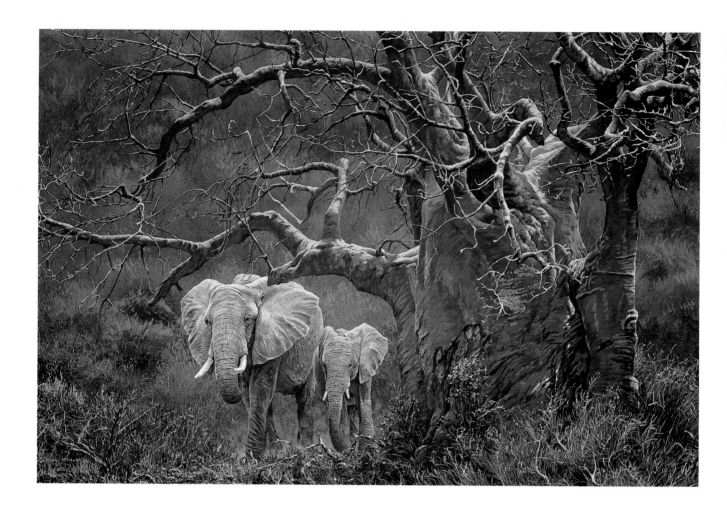

## AFRICA'S PRECIOUS HERITAGE

*1993, gouache, 20½" × 30½" (52 × 77.5 cm).*

The paintings on these pages represent two different approaches to the same subject. In the first, African elephants are seen in the landscape; in the second, an elephant is the landscape.

In *Africa's Precious Heritage,* a cow elephant and her calf pass under a baobab, one of the oldest tree species in the world. Both are disappearing from the African landscape—the elephant because of poaching, and the baobab (also known as the elephant tree) because elephants and other animals rip it apart for the water stored in its trunk. Sometimes the huge trees collapse and kill the elephants, a double loss.

The elephants are shown in strong light to counterbalance the great dark mass of the tree, whose bark glows with purple tints reflected from the surroundings.

The network of branches contrasts with the softly painted background scrub. In places, the branches are as strongly lighted beneath as they are above. Yellow highlights provide a complementary contrast to the purple, enlivening both hues.

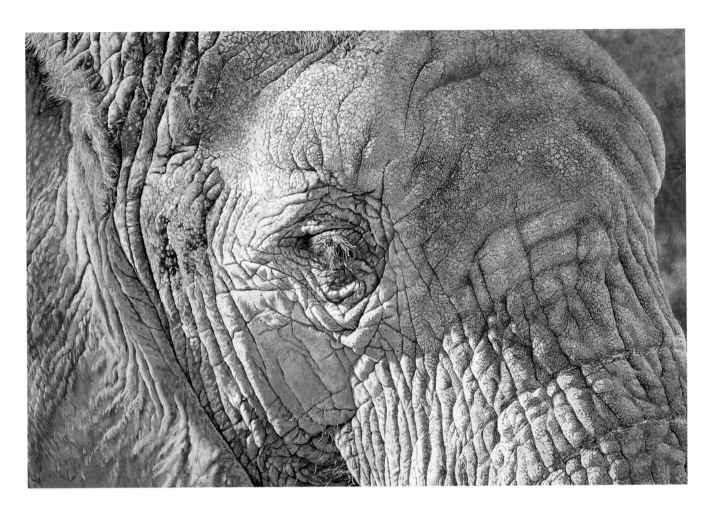

## African Contours

*1992, gouache, 20" × 29½" (51 × 75 cm).*

*African Contours* was inspired by an experience in the bush. "We were watching a herd of elephants cross a dried-up river bed, and we went ahead of them to get some nice pictures. But they disappeared," Hunt recalls. "We were in scrub, not heavy jungle, and it was quite light. We had been sitting there about half an hour when we realized the elephants were all around us, some only a few feet away. They can be incredibly quiet. One elephant was so close, all I could see was its eye."

Hunt chose this challenging perspective to force himself back to the discipline of painting after being away from the studio for three months. "I wanted something difficult that I knew would take a long time and needed full concentration," he explains. "Painting the texture of an elephant's skin is almost impossible," says the artist, who has had years of professional experience. "You've got to paint every single shape formed by the crisscrossing of the hide. It's very hard to do accurately, and there's no easy shortcut."

Hunt covered his illustration board with a warm mixture of burnt umber and yellow ochre, then went in with his darks and painstakingly painted all the lines, folds, and shadows. Working from top to bottom, he built up the lights, for which yellow ochre was his lightest color. Then, for the sunlight that floods across the ear, he added white to the yellow ochre and created many little highlights. Finally, tiny pinpricks of paint, stippled with a No. 1 sable brush, conveyed the dry brittle area between the eyes.

Says Hunt: "After years of visiting Africa and painting elephants with different backgrounds and in many situations, I felt I could say as much about Africa, its terrain, these magnificent animals, and the great age they attain with a simple study of an old matriarch's eye. The title encompasses all these elements."

# Achieving Texture with Watercolor
*Morten E. Solberg*

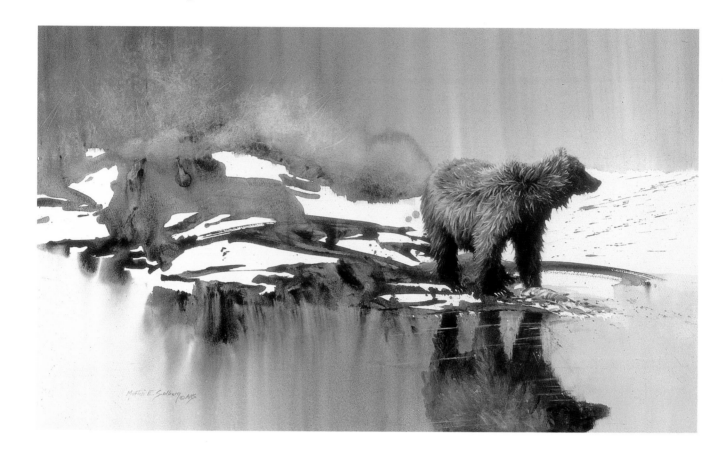

## Bad Water Bear

*1987, watercolor, 22" × 30" (56 × 76.2 cm).*

Mort Solberg started *Bad Water Bear* working drily and rapidly and then moved to working wet. "If I want to blend an area and soften it, I just drag across a small brush that's full of water, and it will bleed and run and give a ragged edge or a soft, blended edge," he says. Using an old Bristol brush, he often uses gesso applied in thin wash layers to soften a color.

Often Solberg will dab a sprayed area with a tissue to create texture. He prefers not to use salt for the similar effect it creates because he can't control it. In *Bad Water Bear,* the billowing along the horizon was done with a tissue, the paint blotted while it was semi-wet. The artist then used the hard end of a brush to incise fine lines indicating sagebrush.

For tighter definition, the bear, fish, rocks, water, and the bear's reflection were painted in acrylic. He left the unpainted white of the board for the snow patches.

Solberg encourages his students to work loose, take chances, and enjoy the medium. "Watercolor is a game of skill, like playing golf," he says. "You mess up and you mess up, and then all of a sudden it works. It's unique. There's nothing else like it."

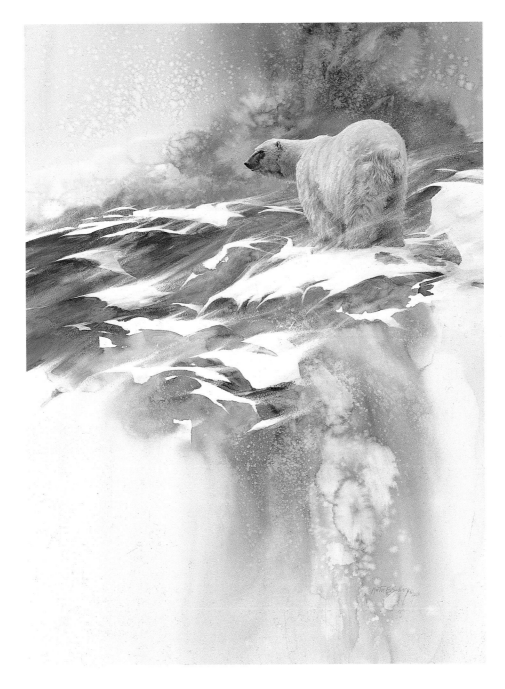

# ICE BEAR

*1992, watercolor and acrylic, 30" × 32" (76.2 × 81.3 cm).*

Dry-brushing, spattering, and blotting a watercolor give it texture, and other special effects add interest. Mort Solberg's wet-into-wet paint blossoms in the foreground and along the horizon of both *Ice Bear* and *Bad Water Bear* were made with a spray bottle and a tissue. The size of the water spots is determined by the drying stage of the paint. Spraying water into very wet paint produces big, fuzzy halos. As the paint becomes drier, the spots become progressively smaller, tighter, and sharper. If the paint is completely dry, spray it, wait about 30 seconds, and then wipe across the area quickly to pull out a pattern that helps suggest space and volume.

*Ice Bear* was the first print that Solberg's company, Graybear, published. The polar bear serves as both a logo and a symbol of the artist himself—a burly 6' 4" man with grizzled hair. "I love doing bears," Solberg says. "There is so much power there, and they're alone—just like most artists who work at home." Using very little water and using a drybrush technique allowed him to get the crisp, white edges that make the painting sparkle.

Spatterings with a brush, seen in the foreground, were carefully orchestrated. "You don't just throw paint in there for decoration; it's meant to lead the eye and give dimension," the artist advises. The effect, made by flicking the brush at different angles to the paper, sets the lighter tones into the background and brings the darks forward for an ethereal effect.

# BLENDING REALISM WITH ABSTRACTION
*Morten E. Solberg*

*Solberg applied thin layers of gouache, which allowed him to blend. "Since the gouache is porous, I can come back over the top with more watercolor," he says.*

## MOUNTAIN VISTA

*1986, watercolor, 30" × 22" (76.2 × 56 cm).*

The landscape is dramatic, and at first glace the viewer may not see the two mountain goats on the precipice at left. Small-scaled animals rendered in detail in a large semi-abstract space are Mort Solberg's trademark. "I like the viewer to discover the animal only after looking at the rest of the painting," he told *American Artist,* which commissioned the work. "I want the viewer's eye to settle in on that smaller shape or be drawn to it by the flow of other forms." By keeping the scale small, the landscape overshadows the animal subject, and the mood of the scene dominates.

Solberg doesn't plan where he will place the animals, so he can't mask out the space for them ahead of time. "Besides," he says, "that would defeat the spontaneity I am trying to achieve. And by not having a subject in mind from the start, I can end up with any subject I want to."

The price he pays is that he must overpaint the subjects in white using opaque designer's gouache, which can give a chalky effect. Solberg compensates by going back over the area with watercolor to freshen it up. "You must add pure colors to the opaque to counteract its tendency to dull and gray down," he advises. "Mix clean oranges or reds with your burnt sienna, and bring some Winsor blue, cobalt blue, or ultramarine blue into the opaque Payne's gray." The trick is to work both quickly and carefully glazing the transparent watercolor of the opaque pigment.

*Mountain Vista* may look like a two- or three-color painting, but it actually contains eight or nine. In addition to thin washes of gesso, the goats have some alizarin crimson, a touch of orange, and some sepia in their coats, as well as hints of blue, black, and green. Some of the background Payne's gray was used to create the texture of fur and relate the animals to the rest of the painting. When the mountain goats were finished, the artist went back into the scene to add more darks wherever they were needed for counterbalance.

Solberg uses T. H. Saunders or Crescent illustration board and synthetic and sable brushes for both watercolor and acrylics. He works flat, to keep control of edges, and rapidly, to achieve spontaneity, often completing a painting in just a few hours (after agonizing for many hours over the composition).

He starts with a 2" flat brush and fresh, generous blobs of color on his palette. His paints are soft and liquid so he can add water and get a lot of rich color quickly. Usually he picks up three colors at a time, and they flow together as he lays them down.

Solberg's palette covers the full spectrum. "Maybe I'll use only five colors, but at least the rest are there so I don't have to search for them while I'm painting," he says. "Especially at the start, I'm working fast and wet, and I don't want to have to stop, put the brush down, open the tubes, and squeeze color out, then go back to painting."

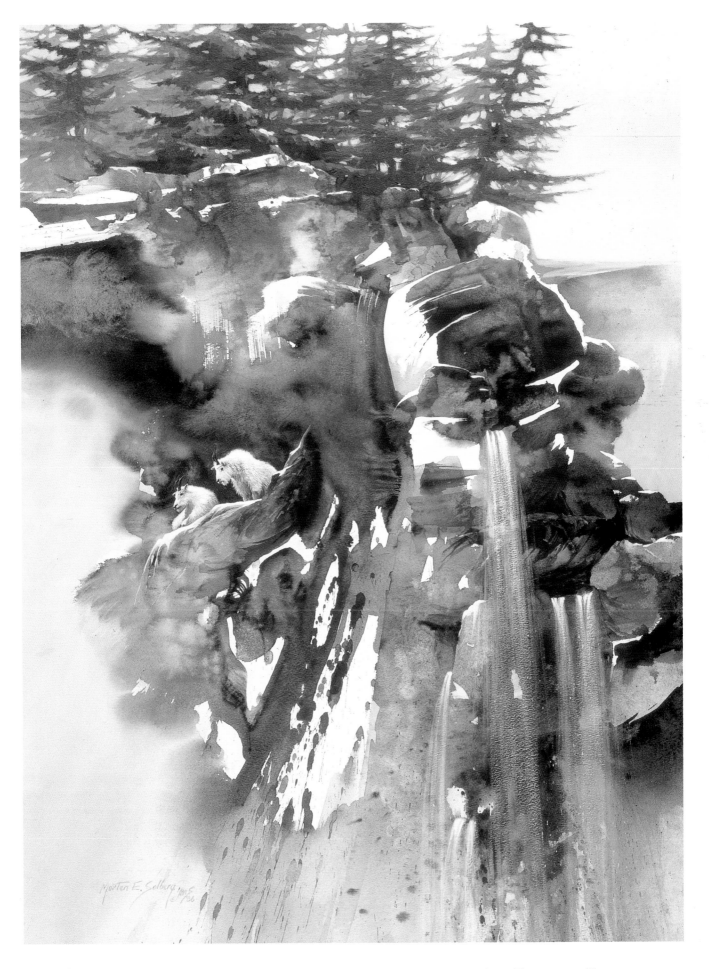

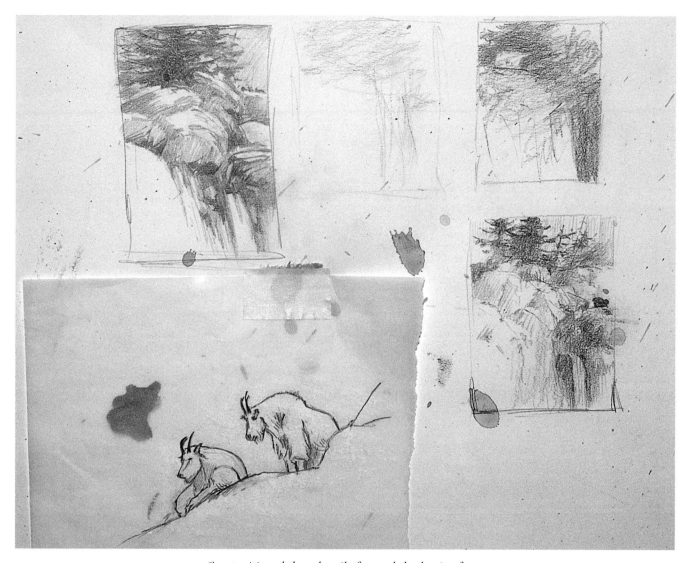

*Compositional thumbnails formed the basis of*
Mountain Vista. *The mountain goats were traced*
*from a color print and moved around on the*
*nearly finished painting to determine placement*
*and scale.*

Solberg chose rocks and water as the theme of *Mountain Vista,* then left the rest to spontaneous inspiration. Working rapidly, he covered a dozen large illustration boards with splashes of Payne's gray and burnt sienna. His third effort in this series is the one he chose to work on: "The way I paint," he says, "is to work from the right side of the brain and then stand back to see if an exciting shape or unusual color happens. In this case, it took a while to loosen up before I realized the third one was pretty good."

After the initial strokes, it was a question of seeing how the shapes would work, from the treeline to the waterfall, through the painting. The artist went back in and "carved" boulders out of white—that is, laying in the shadows beneath them so they looked round and full. "I do a lot of reverse painting—putting the darks in and pulling colors out, working darks against the light," the artist explains. "It's the whites and darks that make the painting."

Solberg worked transparently until he felt it necessary to switch to an opaque medium to cover background colors. Then he finished with opaque paint, tightly rendering his subjects. He usually doesn't pick a subject until he is almost done. One piece started out as a painting of a fisherman and ended up one of a polar bear. "It just felt colder and colder as I went along," he said.

*Solberg started at the top, laying in big abstract shapes in Payne's gray and burnt sienna.*

*Adding water, he extended and diffused the color to create a softly blurred effect.*

*As he worked down the board he created large wet-on-dry and wet-into-wet patterns. Splatter effects were made with a water bottle and a brush.*

*The dark mass at the top suggested trees. Middle passages turned into boulders. And dark clouds of Payne's gray, softened with designer's white gesso, became deep shadows. A burst of cadmium red enlivened the scene.*

# CREATING WILDLIFE LITHOGRAPHS
## *John Seerey-Lester*

## GORILLA

*1989, lithograph, 25½" × 37" (64.3 × 94 cm).*

The success of John Seerey-Lester's wildlife paintings has led to his creation of a series of hand-colored lithographs. The artist paints directly on Mylar, a translucent polyester drafting film. The image is then burned onto a photosensitive printing plate and the print is hand-colored, in a process that can take days.

"The challenge was to imagine how my initial painting would look reversed, which is how the image appears when it is finally printed," the artist notes in his book *Face to Face with Nature: The Art of John Seerey-Lester*. He also had to get used to reversing positive and negative shapes. He used a mix of ink and "something else, a well-guarded secret" to get a very dark black. To create the image, light comes through whatever is not covered.

In *Gorilla,* the shoulder fur was painted in acrylic using ultramarine blue and burnt umber, then scratched off with fine sandpaper. Sanding into the paint gave it a soft edge. Highlights in the ape's eyes were made with a scalpel. The print was enhanced with subtle washes of Payne's gray on the nose and brow, raw sienna in the eyes, and burnt umber mixed with burnt sienna on the forehead.

The success of the lithograph inspired the painting *Face to Face* (pages 104–105).

# SPOUT

*1990, lithograph, 23½" × 35" (58.4 × 89 cm).*

The idea for *Spout* came from watching humpback whales in Alaska, whose spouts were illuminated by the sun against a dark, mountainous shoreline. Seerey-Lester picked the delicate spout out of the blue-black background with a sponge, protecting his work with fixative as he went along. The base of the spout was softened with sandpaper. He painted the water in acrylic burnt umber and ultramarine blue, then went over it with printer's ink and a special ingredient, which he manipulated like pastel with a finger.

# Painting Animals in Herds
*Leigh Voigt*

## IMPALA

*1973, watercolor, 7¾" × 14½" (20 × 36.5 cm).*

Animal herds are like musical scores to South African artist Leigh Voigt: "When you see ten or so animals standing together, it makes a lovely rhythm," she says. "Little notes in one place, then dot, dot, dot . . . and then another little note farther away."

If you create a rhythm, you will avoid making stilted wildlife paintings, she believes. The secret lies in the way you group the animals, based on an interplay of shapes, patterns, colors, and spaces. "Take it beyond the 'chocolate box' picture of the scene," Voigt advises. "Make a statement of how you feel about it. When I go into the bush, I look at dappled light and shade or other patterns which complement those of the animals themselves."

Looking at a photograph of a herd, Voigt selects a pleasing clump of animals, then adds a few isolated ones, or she gathers a scattered grouping and moves them up along a single line. "It's just a feeling of how they should be on the page," she says. With the impala, she was attracted to the shapes and markings of their delicate heads and tails against a dark background, and to their slender legs tapering to white. The background consists of cerulean blue plus raw sienna, with a touch of cobalt blue.

Many less experienced artists would start a wash at the top of the page and end up battling rapidly drying paint as they struggled around the complex shapes of the animals' heads and ears. Instead, Voigt recommends, turn the paper upside down and start by going around the animals with a watery wash, adding more pigment with each successive wash until you reach the edge of the paper. "You've got to work very quickly," she says. "And if you've got too large an area, you're going to get into trouble. In fact, you've got to have rather thin bands of wash to make it work."

*Zebra,* 1967, ink, 29″ × 40″ (73.7 × 101.6 cm).

*The zebras, done in ink on tissue paper,
were printed with a zinc batik printing plate.
The artist visualized the animals not as
individual animals but as a pattern of stripes.*

*Voigt was struck by
the curve of the
horns on the sable
antelope, which
echoes the patch on
their rumps. The
one standing alone
makes the rhythm
work.*

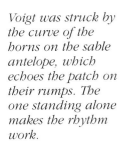

*Sable Antelope,* 1982, watercolor, 29″ × 40″ (73.7 × 101.6 cm).

# DEVELOPING PAINTINGS FROM DRAWINGS
*Dino Paravano*

## STRIPES

*1995, oil, 30" × 24" (76.2 × 61 cm).*

Dino Paravano has spent most of his life in Africa and knows the landscape. The wildlife is plentiful and accessible on the wide open plains, and the sun is strong, causing shadows that give contrast and depth. . "I greatly enjoy the preliminary field work, especially in the hot and dry African bush and semidesert," he says. The artist's favorite areas are the Etosha Pan National Park, in Namibia, and two South African preserves: Kalahari Gemsbok National Park and Kruger National Park.

In the evening, after natural light has left the sky, Paravano turns from painting to drawing. Some subjects are developed from sketches, others from photographs. Most become the basis for paintings in oil, watercolor, or pastel.

Using drawing pencils ranging from hard to very soft—H to 9B—he plays with ideas, combining animals from various sources, merging separate drawings, and moving his subjects around.

"Although most of my paintings are executed in the studio, they really start in the field," the artist says. "I believe the most important thing is to observe the scene—not just to see it superficially but to look deeply into it, taking careful note of colors, shapes, textures, and the relationships between objects."

The drawing of zebras shown here (bottom left) was the basis for the oil painting above. The group of lions opposite—three teenagers and their mother—inspired a painting that turned out to look quite unlike the drawing. Paravano can make a number of different paintings from such a start, and the elephant herd (top right) will probably contribute to several future paintings.

*Though his drawing is less than half the size of the painting (above), it was there that Paravano worked out the painting's very precise design.*

*Stripes,* 1995, pencil, 14" × 11" (35.6 × 28 cm).

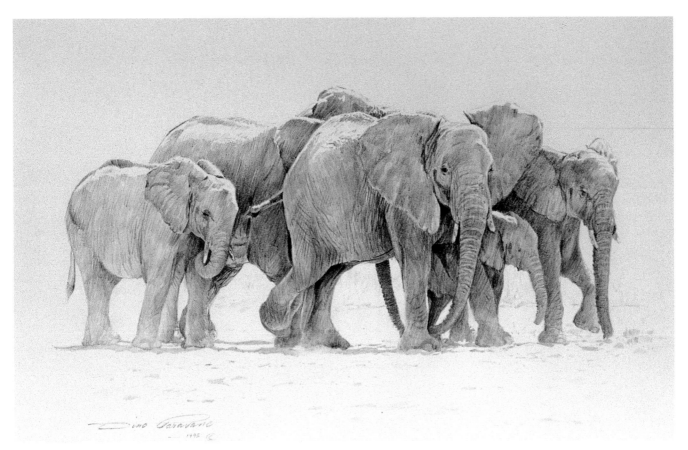

*Walk in the Dust,* 1995, pencil, 10″ × 14″ (25.4 × 35.6 cm).

*For this drawing, Paravano worked with 2 to 6B pencils to achieve a uniform tonal value throughout.*

*This study of a cantering wildebeest is typical of Paravano's skillful drawings, done with tight, spontaneous strokes.*

*On the Run,* 1994, pencil, 9″ × 12″ (22.9 × 30.5 cm).

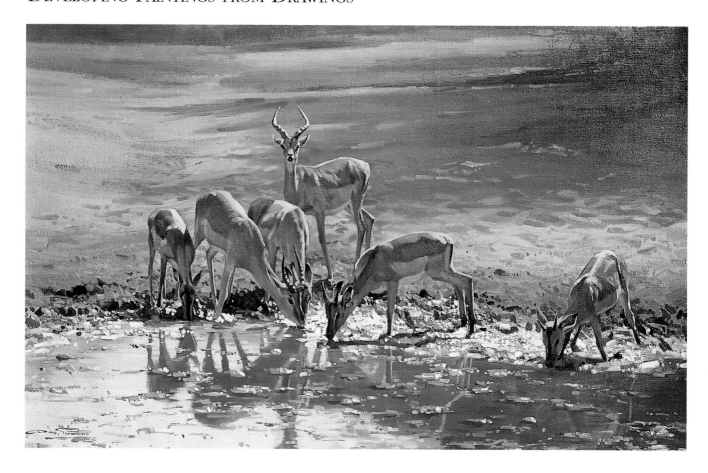

## Impala at Waterhole

*1984, oil, 24″ × 38″ (61 × 96.5 cm).*

At a watering hole in the Mkuse Game Park, a Zululand preserve, Paravano has used oils to depict impala nervously getting a drink at sunset. "I am inspired by an animal's spontaneity, beauty, and freedom of movement in a natural habitat," he says, "and by the excitement of predators hunting, and the alertness of the animals in their quest for survival."

Paravano begins an oil painting by drawing the outline in pencil, charcoal, or pastel, and then painting the outline on a canvas with oil color thinned with turpentine, or he may use acrylics. Next he blocks in masses in thin, almost monochromatic, washes and then, using a more solid opaque paint, works from middle tones to dark, finishing with highlights and accents. "That way, I can see if the painting pulls together," he explains. His method with oil is *alla prima*, working as much as possible while the paint is wet. Oil provides rich, deep, strong colors that can be warmed or cooled by glazing. Pastels, on the other hand, convey a soft effect, but once applied, their color harmony can't be changed.

With pastels also he works on the whole painting at once. Paravano favors using pastel in dry weather, for humidity seems to change the

*Duel in the Desert,* 1992, pastel, 21″ × 29″ (53.3 × 73.6 cm).

*Paravano captured the heat and dust of the Kalahari in this painting of two oryx antelope fighting. For the dust, he used a gray-beige pastel, making soft strokes for a transparency at the top and getting progressively more opaque at the bottom, where the dust casts its own shadow.*

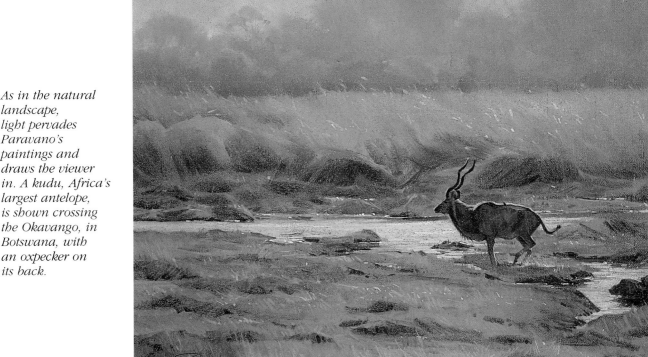

*As in the natural landscape, light pervades Paravano's paintings and draws the viewer in. A kudu, Africa's largest antelope, is shown crossing the Okavango, in Botswana, with an oxpecker on its back.*

*Across the Swamp,* 1991, pastel, 21″ × 29″ (53.3 × 73.6 cm).

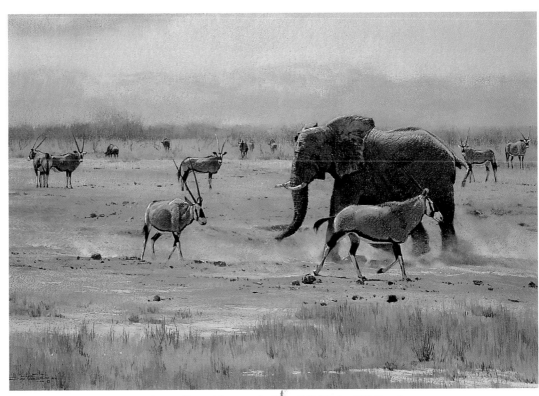

*An elephant bullies oryx and wildebeest at a waterhole in Etosha National Park, in Namibia.*

*The Bully,* 1994, pastel, 28″ × 42″ (71.1 × 106.7 cm).

soft bloom. Rainy weather inspires watercolors. Asked which medium he prefers, Paravano responds, "the one I'm going to use next. That's because, while I am battling with one medium, I wistfully wonder if another would have been a better choice."

# DETAILING SPECIFIC LIGHTING CONDITIONS
*Carl Brenders*

# Power and Grace

*1993, mixed media, 27¼" × 39" (69.5 × 99 cm).*

Four deer stand on the alert in a meadow in the late afternoon sun. Ears pricked like radar and poised to run, they are the essence of wildness. Yet they seem close enough to touch. "What I paint is nearly impossible to see in the wild," comments Carl Brenders. "In my nature scenes I like to share the experience of being within the intimate world of the animals—like a moment in paradise."

In fact, these deer were so far away that Brenders needed a 600mm lens to photograph them at a game farm in Vancouver, British Columbia. When the film was developed, it was the setting, as usual, that inspired the theme—particularly the way the sun in one photograph caught the marsh grass. "This is the light I want in my white-tailed deer painting," the artist decided. Because afternoon, more than any other time of day, reflects blue, he gave their coats a bluish cast by mixing natural gray with yellow ochre. Here and there he used a bit of burnt sienna as well, but in general Brenders avoids brown. "If you mix too much brown (which contains red) with neutral gray (which contains blue), you end up with purple," he cautions. Just about the only brown he used here can be found on the rump of the buck, painted in sepia and highlighted with a mixture of brown and cadmium yellow—a favorite combination to warm and enhance browns.

The sheen on their backs was made by dragging a thin wash of white gouache mixed with a bit of ultramarine blue to allow the underlying color to show through. The eyes were done with sepia watercolor, which looks almost black when applied straight from the tube. The only problem when it is used opaquely is that it tends to look shiny. The deer standing in the shade have neutral gray eye highlights to indicate reflections from the sky. Those in the sun have white highlights mixed with a bit of yellow ochre. The warm light on their bellies was laid in with Winsor & Newton cadmium yellow deep, the artist's favorite sun-reflection color. Brenders "matured" the young buck by making its body heavier and adding antlers.

To paint the marsh grass, Brenders made quick vertical lines in watercolor and gouache, stroking in random directions using both lights and darks. He also went in with an airbrush to blend and soften, and then finished off the details in dark colors. The darkest green consists of dark brown mixed with Prussian blue. The medium green is olive, with a bit of neutral gray added for the areas in shadow. The grass in sunlight is a combination of yellows and white in the brightest passages.

Deer are surprisingly difficult to paint, Brenders has found: "It's because of their special character. They have a kind of proudness, an elegance." One print of the work was purchased by a hunter who had waited twenty years to find just the right image of white-tailed deer. "He knew very well how they looked, and was never happy with what he saw until then," Brenders says. The limited-edition print sold out immediately.

# Detailing Specific Lighting Conditions

To achieve the extraordinary detail in his work, Carl Brenders paints on illustration board using mainly a Winsor & Newton sable watercolor brush, Series 7, No. 2. Why is he so fascinated with every blade of grass, every thistle?

"It is my soul," he responds. "I never can stop—I am obsessed by the reality of things, and I want to go to their essence. When I see a leaf on a tree, I don't want to just experience that it looks green. I want to see its texture up close, I want to see how it looks in sunlight, and I want to see how it looks underneath, with the sun shining through."

*Brenders drew the deer on the board, and gave the grass a watercolor wash in green tints.*

*Once finished, the watercolor background was ready for airbrush accents.*

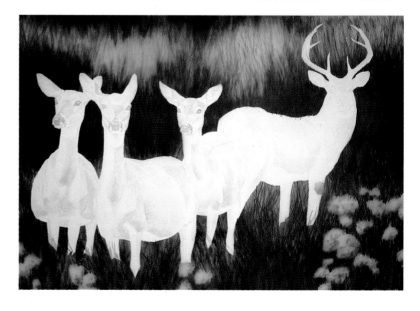

*With an airbrush, the artist blended and softened the grass. The deer were masked during this process.*

Brenders exhibited a major talent early on and has been drawing and painting ever since. "For me it is easy," he concedes. "When I explain it, I have to imagine the struggle some people have. Then I realize the main thing is long years of experience and a big desire to get the realistic effect." For those who are having a hard time, he offers the message: Don't lose heart. "Some students get good grades in school very easily. Others need to study harder to get the same results. That's also true with painting."

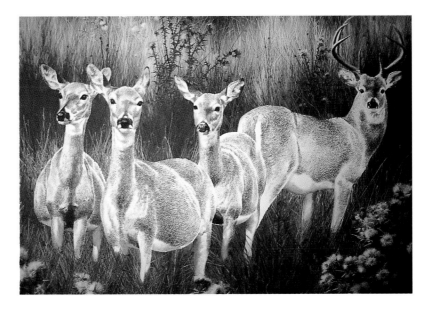

*The value contrasts of the composition are strengthened with sepia watercolor.*

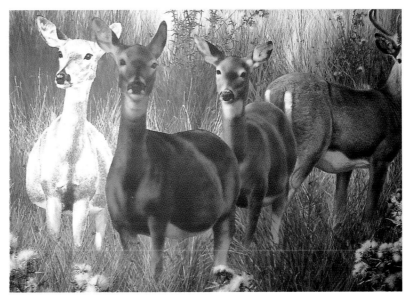

*Here, three stages of progress can be seen: The buck, at right, has been finished in gouache, and two does have been airbrushed. The doe at the left is still in the sepia phase.*

*Details on thistles at the lower right corner of the painting were begun in sepia, over an airbrushed base. The stems were completed earlier, when the grass was done. The thistles were finished in gouache.*

All photos © 1993 by Carl Brenders.

# WORKING OUTDOORS
*John Seerey-Lester*

*"Animals are going to strike the same pose over and over again if you are patient enough to wait for it," says Seerey-Lester. Here, he did a study in acrylic of characteristic poses of mountain lions in Canada.*

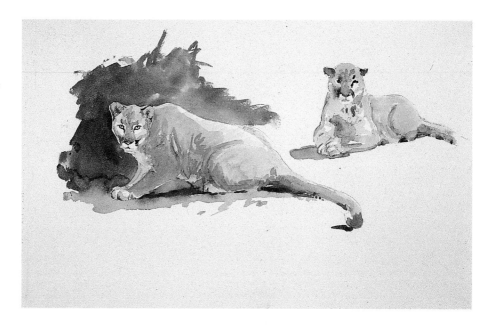

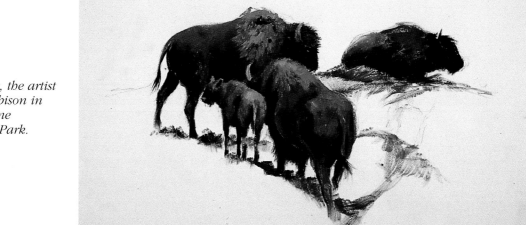

*Using oils, the artist sketched bison in Yellowstone National Park.*

Sketching outdoors often means coping with the sun's glare and, in wildlife painting, with subjects that tend to wander away. John Seerey-Lester always faces into the sun to avoid having a glare on his panel or canvas. This hurts the eyes and bleaches out values. When painting in the field using acrylic, he scouts the area the day before to pick the best location and observe how the sun will arc. Then he sets up his equipment several hours before the sun is in its optimum position, to get all the details down beforehand and be ready to put in sunlight and shade at the right time. When working in oil, the artist lays in the lights and shade at the start of the painting and never changes it. "Once you start trying to chase the sun, the whole painting becomes flat," he explains.

When sketching wildlife, the artist advises, capture the subject's gestures quickly and then note down colors and the direction of the light source and shadows. That way, if the animal moves out of range, you can continue the sketch as a memory painting based on the notes you've made at the scene.

Animals repeat patterns of movement, so if you missed something the first time, be prepared to catch it later on. "If a moose is walking from right to left, I will try to capture that. If it turns and does something else, I'll start another drawing of that. Then if it decides to come forward and graze, I'll do a sketch of that," says Seerey-Lester. "Eventually, it's going to walk from right to left again, and I can go back to the original sketch and put in its body or work on another leg."

*A grizzly bear emerges from a snow hole in this acrylic sequence.*

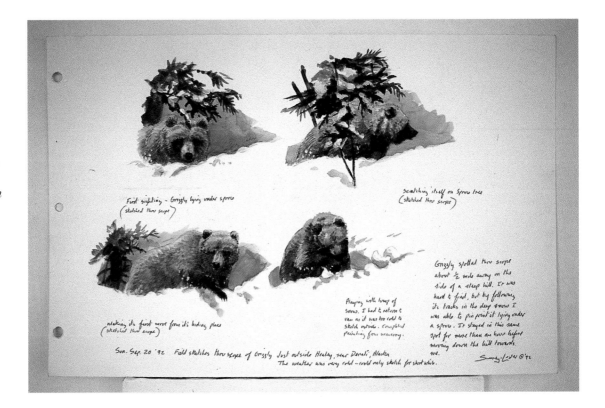

John Seerey-Lester regards his field sketches as learning exercises: "The sketch may not be very good," he says, "but what has registered in my brain is very helpful when I go to do the painting." On the sketches — executed in acrylic or oil on hole-punched 12" x 17" paper — he makes notes on color and observations about his wild subjects.

*This grizzly, sketched in with the landscape, was observed in a snowstorm.*

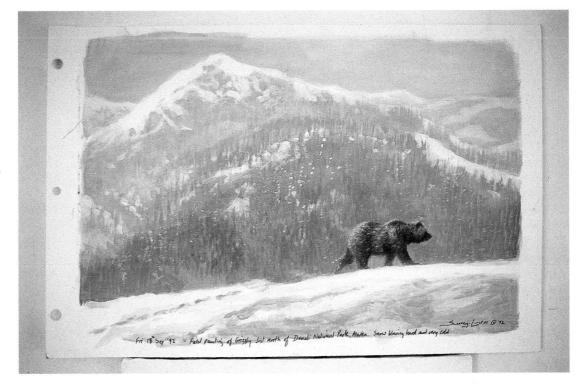

# WORKING OUTDOORS

*Seerey-Lester makes many of his on-location sketches in 6" x 9" journals using watercolor.*

*Sometimes Seerey-Lester dry-mounts canvas on 9" x 12" Masonite or foam-core panels so he can paint in oil on canvas in the field.*

The key to working in the field is to be organized and travel light. Over the years, John Seery-Lester has turned field work into a fine art. He has different pieces of equipment, stored in different kinds of boxes, for different trips, depending on the need.

Sketches made during the artist's travels are recorded in a 6" x 9" journal, one for each trip. Everyday sketches are kept in similar journals and dated. His only watercolors are sketches done on location in these 6" x 9" journals: "I've never done a major piece in watercolor. I'm not skilled enough in that medium," Seerey-Lester explains.

He makes other field sketches (such as the ones shown on pages 128–129) on three-ply, kid finish Strathmore paper that holds up to watercolor, acrylic, and oil. It is hole-punched and cut to fit a 12" x 17" financial ledger. He carries the sheets sandwiched between two Masonite boards, which he uses for support. Back in the studio, he puts the sheets into the ledger in chronological order.

The artist prefers acrylic or oil for detailed field paintings and studio work. For painting on location in acrylic or oil, he also dry-mounts paper sheets on foam-core panels cut to 9" x 12" or 12" x 16" sizes. He works in acrylic on 9" x 12" Masonite primed in a gray or an earth tone.

*Seerey-Lester's field equipment includes a Kowa scope (at right) for long-distance observing. His pochade box is shown here mounted on a tripod — below that, a separator box for wet panels and a set of brushes.*

Field sketches in oil require paintboxes of various sizes, with storage slots to keep the panels separate. For acrylics, the artist uses a lap box, the lid of which acts as an easel. He also has a 9" x 12" pochade box containing two slots to hold oil paintings on canvas, dry-mounted foam-core and Masonite panels, or Fredericks brand canvas panels. A tripod screws into the bottom of the box for use on uneven ground — "a lot easier to use than a French easel," says the artist. His half–French easel, a smaller version of the standard French easel, is 10" wide, and can hold paintings up to 36" x 24".

Seerey-Lester also takes along a Kowa scope for long-distance observing. This mounts on a tripod like a camera and comes with several eyepieces. He prefers the wide-angle 30x eyepiece, which lets him look down into it to view the subject rather than straight ahead at eye level. This way, he can paint flat on his lap or standing while looking through the scope and at his panel or sketch book at the same time.

Seerey-Lester owns a range of canvas folding stools and chairs. He carries his gear in a backpack, storing everything else in a large wooden crate that stays in the car.

# Biographies
# of the
# Artists

*Carl Brenders*

*Alan M. Hunt*

*Terry Isaac*

*Lee Kromschroeder*

*Dino Paravano*

*John Seerey-Lester*

*Richard Sloan*

*Daniel Smith*

*Morten E. Solberg*

*Leigh Voigt*

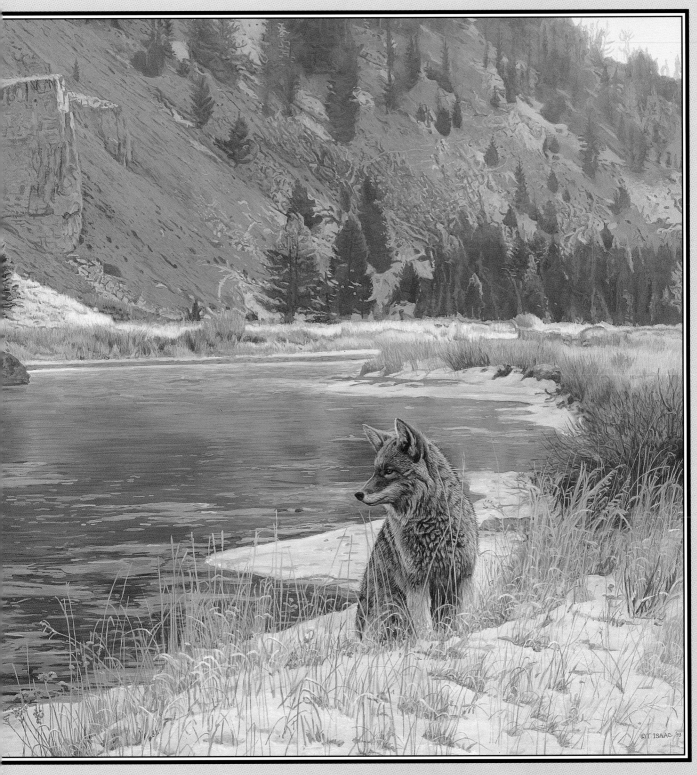

Terry Isaac, *Along the Gallitin—Coyote*, 1993, oil, 36″ × 24″ (91.4 × 61 cm).

# CARL BRENDERS

Carl Brenders' meticulous realism has earned him an international following. Born in Belgium, he began drawing as a child during World War II air raids as he hid with his family in their cellar.

Brenders studied at the Fine Arts Academy in Antwerp. In the 1960s, he worked in the printing business, then as a book illustrator, and later as a freelance commercial artist and wildlife illustrator. He illustrated five books in a children's nature series called *The Secret Life of Animals.* Today his wildlife paintings are widely collected in North and South America, Europe, and Japan.

Brenders lives with his wife Paula in their country studio home in Belgium, a respite from constant travel, field trips, and shows. A late riser, the artist enjoys gardening during the day, then paints into the late hours as he listens to classical music and the BBC. He makes frequent trips to the United States and Canada, visiting national parks and nature preserves. Since 1983 he has made annual visits to Yellowstone National Park, where he gets many ideas for paintings. Such areas reinforce his deep convictions about the importance of wildlife conservation.

Brenders' work is featured in the book *Wildlife: The Nature Paintings of Carl Brenders* and the video *Windows into Wilderness: A Portrait of Carl Brenders.* He is represented by Mill Pond Press, in Venice, Florida, which publishes limited-edition prints of his work.

*Wolf Study,* 1992, pencil, 17¾″ × 14¼″ (45 × 36 cm).

# ALAN M. HUNT

*Waiting,* 1994, gouache, 15″ × 28″ (38.1 × 72 cm).

Wildlife artist and naturalist Alan M. Hunt has worked with birds and animals both in the wild and captivity, in parks, zoos and reserves around the world.

Born in North Yorkshire, England, Hunt's talent became obvious when he was very young. He pursued his interests in painting and the natural world, attending Middlesbrough Art College, in Yorkshire, and studying zoology at Leeds College and at Bristol University.

Hunt's dual credentials are revealed in his paintings, which are both accurate and evocative. Hunt achieves realism working primarily in gouache and oil but also in ink, acrylic, egg tempera, and watercolor. "I try everything," the artist notes. "I'm not set in my ways. In almost every painting I change something, or try something different."

A devoted conservationist, Hunt is often involved in fundraising efforts to aid endangered species. "Humans are destroying wildlife and the planet," he says. "If my son doesn't get to see in his lifetime half the wildlife I've seen, I'll feel very guilty."

Hunt's paintings appear in international shows, including the prestigious "Birds in Art" and "Wildlife: The Artist's View" exhibitions at the Leigh Yawkey Woodson Art Museum in Wausau, Wisconsin. Limited-edition prints of his work are available from the National Wildlife Federation's nwf editions, in Winchester, Virginia. Hunt is represented by Midge Nelson of Art Haven, in Aspen, Colorado.

# TERRY ISAAC

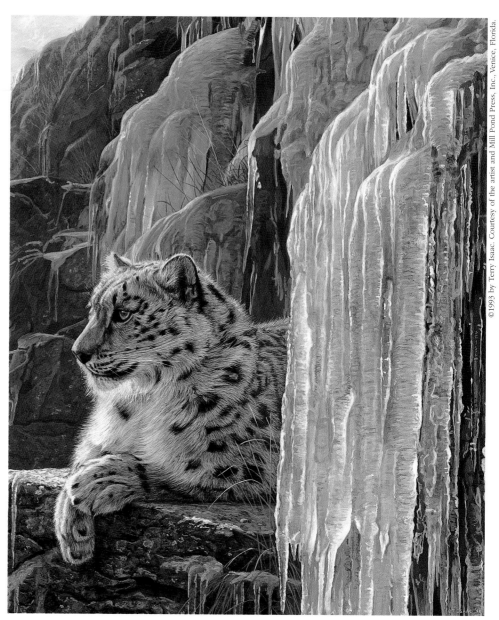

*Crystal Palace,* 1993, acrylic, 22″ × 18½″ (56 × 47 cm).

Terry Isaac is a native Northwesterner living in the Willamette Valley of Oregon an hour from the mountains and an hour from the sea. Although he received a formal art education and taught middle-school art for eight years, Isaac believes his best training has come from being outdoors and from studying the work of his favorite wildlife artists, such as Robert Bateman.

Isaac has participated in several important art exhibitions, including the Leigh Yawkey Woodson Art Museum's "Birds in Art" and "Wildlife: The Artist's View." In 1994, his work was selected for "Wildlife Art in America," an exhibition at the James Ford Bell Museum of Natural History, in Minneapolis.

He has produced fourteen waterfowl drawings for the Audubon Society's *Pocket Field Guide to Birds* (1987) and was commissioned to create the design for the 1991 New York duck-hunting license stamp. Isaac's paintings are published in limited-edition prints by Mill Pond Press, in Venice, Florida.

Born in California, Lee Kromschroeder began drawing as a child, copying art in his grandmother's books. He obtained a B.A. in art from San Francisco State University.

At first, Kromschroeder pursued commercial art, figure painting, and landscapes but his love of the natural environment soon won out. In 1991, he was selected by the National Wildlife Federation as Artist of the Year for his stamp-print painting of Costas hummingbirds.

Since then, Kromschroeder's art has illustrated the covers of various publications. In 1990 and 1992, he was selected as featured artist for the Pacific Rim Art Show in Tacoma, Washington. He was also featured artist for the 1993 Natureworks Show in Tulsa, Oklahoma.

Kromschroeder had several one-man shows at the Americana Gallery, in Carmel, California, followed by acceptance to the Leigh Yawkey Woodson Art Museum's "Birds In Art" exhibition in Wausau, Wisconsin. In 1994, he was named Artist of the Year at the Wildlife West Art Show at the San Bernardino Natural History Museum. In 1995, he was featured artist for the second time at the Prestige Art Show in Toronto and was chosen Artist of the Year for Octoberwest, sponsored by the Southern California Wildlife Artists Association. In 1996, Kromschroeder was selected Artist of the Year at the Pacific Rim Show in Seattle.

The artist lives with his family in Escondido, California. Limited-edition prints of his work are published by Wild Wings, Inc., in Lake City, Minnesota.

*Moon Dancers—Wolves*, 1995, acrylic, 36″ × 24″ (91.4 × 61 cm).

# DINO PARAVANO

*On Alert,* 1995, oil, 24″ × 36″ (61 × 91.4 cm).

Dino Paravano, an Italian by birth, moved to South Africa with his family in 1947, when he was twelve. He fell in love with that country's sun-drenched landscapes and abundance of wildlife and has been painting them ever since.

Since 1992, Paravano has resided in Tucson, Arizona, and has added North American wildlife to his repertoire.

Paravano's accomplishments include fourteen one-man shows and more than 200 group exhibitions around the world, numerous awards, and inclusion in many books on African wildlife art. His pencil drawings illustrate two books by best-selling author Peter Hathaway Capstick.

In 1993, he was chosen Master Wildlife Artist at the annual "Birds in Art" exhibition at the Leigh Yawkey Woodson Art Museum, in Wausau, Wisconsin.

Paravano's work can be found in museums and in corporate and private collections in South Africa, the United Kingdom, the United States, Australia, Europe, and Asia. He is represented by Natures Gallery, in Akron, Ohio; Trailside Galleries, in Carmel, California; Everard Gallery, in South Africa; and the Tryon Gallery, in London. Limited-edition prints of his work are published by Mill Pond Press, in Venice, Florida.

*Moonlight Fishermen—Raccoons,* 1988, oil, 14″ × 48″ (61 × 121.9 cm).

John Seerey-Lester travels the world in search of his subjects. Born in 1945, in England, he worked in the fields of advertising and publishing before becoming a professional artist. He made the decision to paint full-time following several successful one-man shows in 1973. He moved to America with his wife Linda and son John in 1982; they now live in Florida..

Seerey-Lester has been chosen numerous times for the Leigh Yawkey Woodson Art Museum's prestigious "Birds in Art" and "Wildlife: The Artist's View" shows and tours. In 1988 he was selected by Ducks Unlimited Canada as the artist for their 50th Anniversary Stamp and Print Program.

Many of Seerey-Lester's paintings have aided nonprofit conservation organizations, and he has been commended by His Royal Highness Prince Philip for his efforts on behalf of endangered species.

Seerey-Lester is the author of *Face to Face with Nature: The Art of John Seerey-Lester* and *An Artist's Journal: John Seerey-Lester's Impressions of India and Nepal.* He is represented by nwf editions, a subsidiary of the National Wildlife Federation, which publishes limited-edition prints of his work.

# RICHARD SLOAN

Richard Sloan specializes in the world's tropical rain forests, which he paints in a distinctive style. In 1950, at age fifteen, he was the youngest full-time student at the American Academy in Chicago. After graduating, he worked as an advertising illustrator. His real interest was wildlife, and he made frequent visits to the Lincoln Park Zoo to sketch animals. Eventually, zoo director Marlin Perkins hired Sloan as a keeper, and then as staff artist. Sloan became passionate about falcons and other raptors, which influenced his art for many years.

A visit to Guyana in 1969 changed his life. From then on, Sloan's focus was exclusively the exotic birds and animals of the tropical rain forests of the world.

Sloan's work has appeared in magazines, galleries, and museums across the United States and abroad. It has been exhibited at National Geographic, British Museum of Natural History, Royal Scottish Academy, and the Carnegie Museum.

In 1994, Sloan was named Master Wildlife Artist by the Leigh Yawkey Woodson Art Museum, in Wausau, Wisconsin, which annually features the most distinguished exhibits of bird art in the world. Limited-edition prints of his paintings are published by nwf editions, in Sarasota, Florida.

*Collared Aracaris,* 1993, acrylic, 14″ × 8½″ (35.6 × 20.3 cm).

# DANIEL SMITH

*Drifters—Canvasbacks,* 1984, acrylic, 24″ × 36″ (61 × 91.4 cm).

The detail and scientific accuracy of Daniel Smith's work has made him a favorite of limited-edition print collectors and earned him wide acclaim for his conservation stamp artwork.

Smith won the 1988–89 Federal Duck Stamp competition and was named Ducks Unlimited International Artist of the Year in 1988. The designer of more than twenty-five conservation stamps, he was selected as the artist for the National Fish and Wildlife Foundation's 1991 conservation stamp print program.

Smith painted five color illustrations for the National Geographic Society's *Field Guide to the Birds of North America* and is a frequent participant in the Leigh Yawkey Woodson Art Museum's "Birds In Art" exhibition in Wausau, Wisconsin.

Environmental concerns have become increasingly important to the artist, who has used his work to endorse and aid several international programs. In 1989, he created the images for Australia's First of Nation Duck Stamp, and in 1991, the United Kingdom's First of Nation Duck Stamp—a benefit for the Wildfowl and Wetlands Trust founded by the late Sir Peter Scott (himself a wildlife artist).

Limited-edition prints of Smith's work are published by Mill Pond Press, in Venice, Florida.

# MORTEN E. SOLBERG

Mort Solberg is descended from Norwegian whalers, a Great Lakes sea captain, and an Indian princess who married an Irish stagecoach driver. He began his career creating realistic images for the American Greeting Card Company, in Cleveland, Ohio.

In 1968, at age thirty-three, he moved his family to California, where he became attracted to the bold, colorful strokes of the California school of watercolor. Within three years he had shed his commercial ties and had begun fine art painting full-time. "I got some big brushes and big canvases and went loose and crazy," he recalls. Three of his first five efforts won awards.

Today, Solberg is nationally recognized, with paintings in the White House permanent collection, the National Gallery of Art, and many other public and private collections. His art has been on the cover of numerous magazines, including *American Artist*, which chose Solberg as 1986 Artist of the Year.

Solberg is a member of the American Watercolor Society, National Watercolor Society, Society of Animal Artists, Knickerbocker Artists of New York, and Wildlife Artists of the World. He has received awards in major watercolor competitions, including a purchase prize from the National Academy of Design.

Eight galleries across the country carry Solberg's original paintings. He lives with his family in Sebastopol, California.

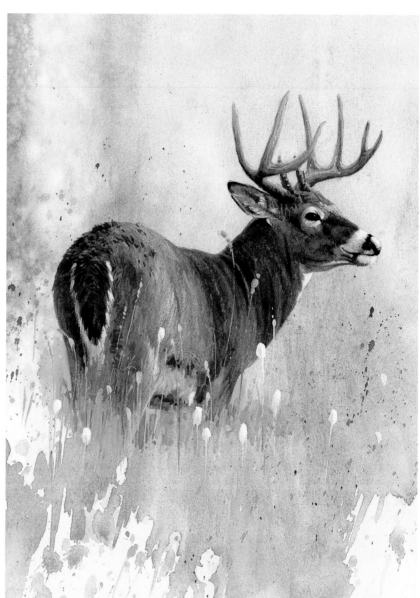

*Commanding View (Detail)*, 1995, watercolor, 12″ × 21″ (30.5 × 53.3 cm).

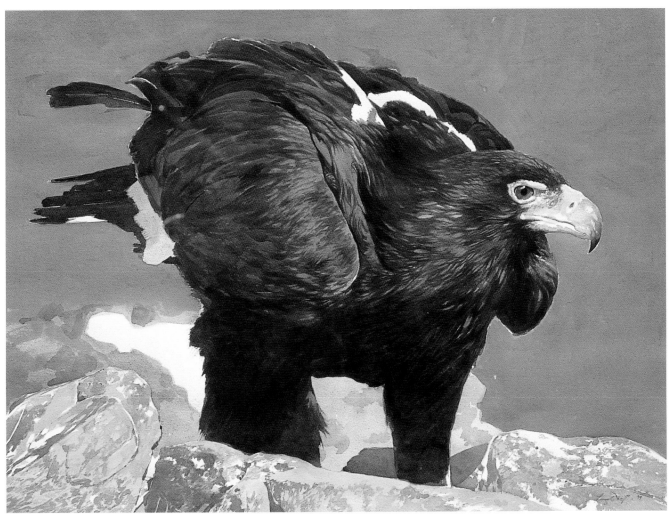

*Black Eagle,* 1994, watercolor, 21¼″ × 29⅛″ (54 × 74 cm).

The wildlife paintings of Leigh Voigt have been shown at major exhibitions around the world. She has won the attention of such prominent art critics as David M. Lank, who praised Voigt for her brushwork and draftsmanship and placed her "among the leading practitioners of her craft in the world."

Born in South Africa, Voigt grew up in an artistic family and remembers visits to Kruger National Park almost weekly to draw plants and animals. She trained at the Johannesburg School of Art, then began her career illustrating wildlife articles and books in watercolor and pen and ink, which she still pursues.

Voigt's work is in the South Africa corporate collections of DeBeers, First National Bank, and others, as well as in many private collections worldwide. She makes her home, with artist-husband Harold and two sons, on a nature reserve in the mountain veld of Schagen, South Africa. Voigt is represented by Clive Kay in Lindsay, Ontario, Canada.

# INDEX